CHRISTMAS CRAFTS
Scandinavian Style

Tone Merete Stenkløv
and Miriam Nilsen Morken

STACKPOLE
BOOKS

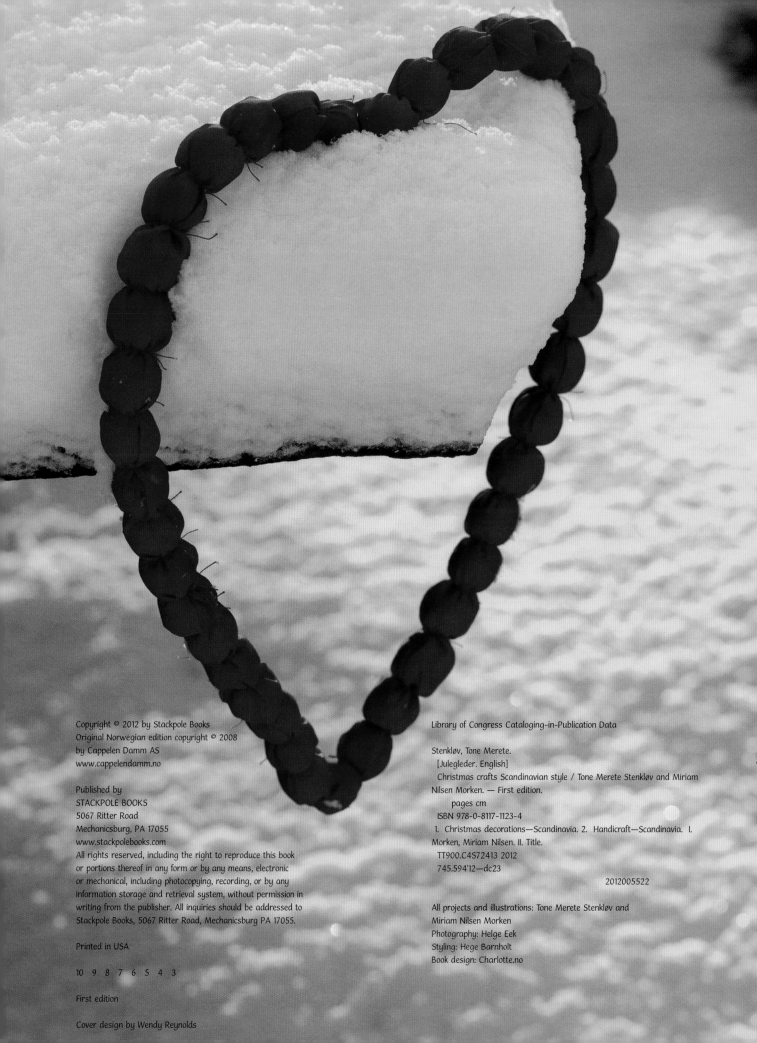

Copyright © 2012 by Stackpole Books
Original Norwegian edition copyright © 2008
by Cappelen Damm AS
www.cappelendamm.no

Published by
STACKPOLE BOOKS
5067 Ritter Road
Mechanicsburg, PA 17055
www.stackpolebooks.com

Printed in USA

10 9 8 7 6 5 4 3

First edition

Cover design by Wendy Reynolds

Library of Congress Cataloging-in-Publication Data

Stenkløv, Tone Merete.
 [Julegleder. English]
 Christmas crafts Scandinavian style / Tone Merete Stenkløv and Miriam
Nilsen Morken. — First edition.
 pages cm
 ISBN 978-0-8117-1123-4
 1. Christmas decorations—Scandinavia. 2. Handicraft—Scandinavia. I.
Morken, Miriam Nilsen. II. Title.
 TT900.C4S72413 2012
 745.594'12—dc23

 2012005522

All projects and illustrations: Tone Merete Stenkløv and
Miriam Nilsen Morken
Photography: Helge Eek
Styling: Hege Barnholt
Book design: Charlotte.no

Contents

A White Christmas

It all started with a local Christmas fair. After being involved in the fair for many years, we had made many products we were very pleased with. Then the idea came that it would be perfect to publish all our ideas and products in a book. You are now sitting with the result in your hands.

To us Christmas is *scents, presents, thinking of others, the message, colors,* and last but not least, *snow.* We hope to spread some of this through our book.

Scents like cinnamon, anise, ginger, and cloves create a nice atmosphere at home. We included some of our favorite recipes and hope that the Christmas seedcake will tempt you with its distinctive smell. Or what about the scent of a fresh Danish Christmas kringle with anise? These are perfect to enjoy at Christmas, or could also be great presents. *Presents* are one of the highlights of Christmas. We included many projects that are suitable for gifts—or you can just keep them yourself. There is something for everybody in this book, whether you are experienced behind the sewing machine or you are just starting. Tips and gift ideas show up throughout the book. We also have some suggestions for wrapping and Christmas cards.

The message reminds us why we celebrate Christmas. And a part of that message is that we should *think of others.* Consideration is always appreciated. Put some extra care into the wrapping of the gifts. For example, if you are giving away a simple bag of candy, wrap it nicely in a fabric bag. Or wrap a flower in a handmade bag. This way, the wrapping is a gift in itself that will last long after the candy or flower is gone.

The traditional Christmas *colors* are red, white, and green. We have used colors and fabrics that are not necessarily connected with Christmas, and we have allowed ourselves to combine the Christmas colors with brown and turquoise. But feel free to make the projects in whatever colors you like.

We live in a mountain district and need *snow* to get the Christmas feeling. Winter-white cornucopias, snow angels, and the winter wreath are inspired by the winter in our town of Oppdal, Norway. If it doesn't snow where you live, be inspired by Helge Eek's beautiful winter photos to get in the right mood.

Welcome! Come with us through the book and enjoy the time just before Christmas!

We wish you a merry Christmas,

Miriam and Tone

Some Good Advice

FABRICS

For most of the projects in this book we have used cotton fabric with different patterns. But we have also used linen fabric—for the cornucopia and ice scraper, for example, and many of the appliqués. The rough structure of the linen makes it perfect for small hearts and stars. Linen is easier to shape and will make the figures look great. We have chosen to use a ready-made padded/quilted linen fabric as well, and we have used different light cotton fabrics for skin for the dolls and angels. We have also used imitation fur in some of the projects.

FUSIBLE WEB AND BATTING

We use fusible web when we are about to appliqué a motif on a fabric. Fusible web has adhesive on both sides. It is first ironed onto the wrong side of the fabric motif, then you rip off the paper that protects the adhesive on the other side, and then you can easily iron the motif to the fabric.

Fusible batting is batting with adhesive on one or both sides.

Quilt batting is a type of batting we use underneath when we are stitching a motif to the fabric. The batting comes in different thicknesses, but it's best to use thin batting for stitching.

PLYWOOD AND WOOD PRODUCTS

We have used 4 mm plywood for hearts, angels, gingerbread, and a Christmas tree in this book. For the Christmas tree calendar (page 100) we've used 18 mm balsa wood. We have used a compass saw to cut the figures.

PATTERNS

All the patterns are drawn without seam allowances. The seam allowance should always be $1/4$ inch unless other measurements are given. Never add a seam allowance when a cutting measurement is given.

Some of the projects, the star-shaped ones, for example, have curved edges or sharp corners. It is a good idea to use a short stitch length when sewing these projects. Cut the seam allowance down to $1/8$ inch and cut a few notches along the seam before you reverse it.

When you trace a pattern, fold the fabric in half and trace the pattern onto the top layer of cloth. Then you can sew around the line before you cut the pieces out. You could also attach the pattern to the fabric with pins and sew around instead of tracing the pattern. Cut clean around the seam, but cut a larger seam allowance around openings that you leave for turning projects inside out.

HOW TO TRANSFER A PATTERN

You can transfer patterns onto cloth with a permanent ink pen or a disappearing ink pen. You can buy disappearing ink pens at arts and crafts stores or fabric stores. If you can't see the pattern through the fabric, you can tape the pattern to a window, hold the fabric over it, and trace the pattern.

You can use transfer paper if the pattern is being transferred to a dark fabric. Transfer paper comes in several colors. You place the pattern on the fabric with the transfer paper in between, and then trace the pattern with a pen. You can also make a template out of plastic and draw around it with a white marker.

We used a permanent ink pen called Pigma Micron 0.2 mm when transfering patterns onto light fabrics. It's important that the pen is not too thick. You can use disappearing ink if you wish. If you do, it will take about 48 hours for the markings to disappear. You can also get transfer pens for light fabrics. To use these, draw the motif on wax paper and iron it onto the fabric.

Techniques

APPLIQUÉS

The appliqué motifs are shown in reverse in the patterns but will end up being the right way when they are appliquéd to the fabric.

1. Draw the motif on the paper side of the fusible web.
2. Roughly cut out the parts and place them with the adhesive side against the back side of the fabric you wish to use. Iron them so they adhere to the fabric.
3. Cut the motif out precisely.
4. Remove the paper from the back side.
5. Place the motifs where you want them on the project, and iron.
6. Sew around the cut edges with blanket stitches.

When several parts are placed close to each other or overlap each other, it is important that the fabrics overlap each other by at least 1/8 inch. Then you only need to sew one seam. Place all the pieces in the right order before ironing.

BORDER

Cut a fabric strip 2 inches wide, fold it in half with the right side out, and iron it. Place the strip edge to edge with the project that needs a border, right side to right side, edge against edge. Always start sewing the border in the middle of a long side, because it's hard to splice the border at a corner. Begin sewing 2 inches from the edge of the fabric strip. Sew with a regular seam allowance (1/4 inch), and sew until you are 1/4 inch from the corner. Turn the piece around while it's still under the sewing machine so you end up with the corner pointing toward yourself and sew straight out to the corner at a 45-degree angle. See figure A. Fold the fabric strip perpendicularly; see figure B. Fold the fabric strip again and place it along the next side. Sew from the top of the edge, down toward the next corner; see figure C. Continue around the whole piece.

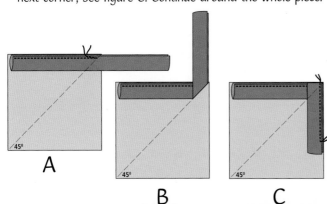

A B C

When you have sewn around all the edges, the strips should be spliced together. Stop 4 inches from where you started and remove the whole piece from the sewing machine. Place the strips next to each other so they meet. Fold the strips back and press with your fingers where the folds meet. Stitch up at the crease, cut superfluous fabric from the strips, and iron the seam. Stitch up the last part of the strip.

Finally, fold over the edge and sew by hand on the back side. When you reach the corner, the border will fold over by itself.

HEMMING

Fold the fabric to the back, 1/2 inch, and iron. Unfold it and fold the cut edge to the previous fold, and iron. Fold the hem over to the back and sew a seam using a sewing machine all the way out by the edge. (See figure A on page 32.)

EMBROIDERY/STITCHING

We use DMC embroidery floss. All the projects in the book use two strands unless otherwise specified. There is a wide range of different embroidery flosses and silk thread suitable for hand sewing.

When we say "stitch the pieces with basting stitches," it means to sew basting stitches across the work in different directions to keep the work in place while you are stitching. This thread is supposed to be removed when you are done with the project. If we say "decorative basting stitches," it means that the basting stitches are there as a decorative seam.

AN OVERVIEW OF THE DIFFERENT TYPES OF STITCHES USED

All the decorative seams we have used can be sewn by hand. If you have a well-equipped sewing machine, it is possible to sew blanket stitches and other decorative seams with the machine.

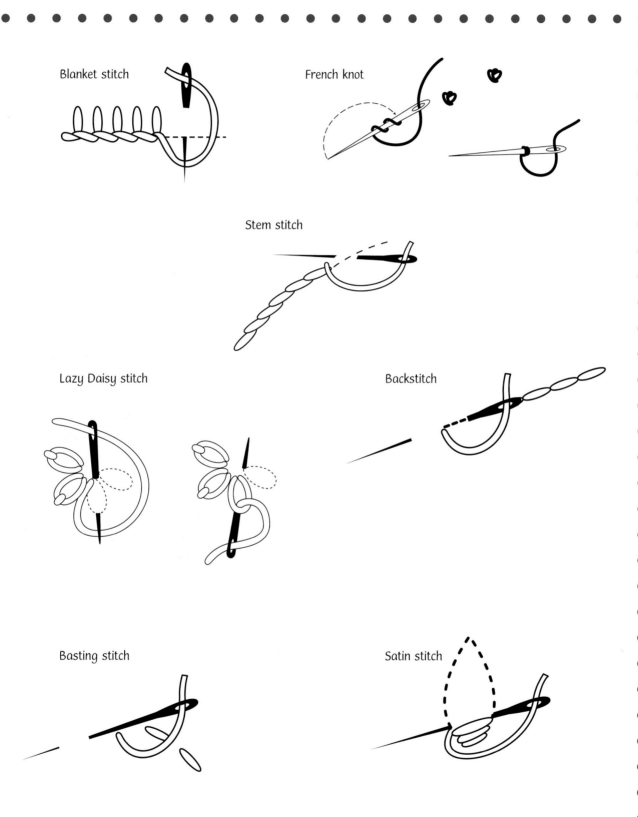

Blanket stitch

French knot

Stem stitch

Lazy Daisy stitch

Backstitch

Basting stitch

Satin stitch

abcdefghijklmnopqrstuvwxyzåäö

ABCDEFGHIJKLMNOPQRSTUVWXYZÅÄÖ

STAMPS AND PAPER

Most craft stores sell stamps and stamping equipment, but if you can't find it where you live, there are many online stores that sell stamps and paper. The cardboard used for the card should be at least 200 grams. The decorative paper can be thinner.

To create an old look on the cards we've used distressed-ink pads. They are so-called hybrid pads with ink made to give paper and photos an old look. It does not lose its original color even if the paper is exposed to water. You will get the best results if you apply the ink with a sponge. Push the sponge against the ink and apply it carefully to the paper.

When you stamp on wood you have to use permanent ink pads. These inks are waterfast and will dry on all surfaces. In this book, we used heat embossing on all the plywood projects with stamp motifs. With embossing you will get a raised stamp. A good ink pad to use for this is by VersaMark. It gives a transparent print that will stay moist for a long time. You also need embossing powder, which comes in many different colors and weights.

HEAT EMBOSSING

Press the stamp to the ink pad, and then press the stamp where you want to place the motif. Pour embossing powder over it until you have covered the motif. Pour the extra powder onto a piece of paper with a fold in the middle. The fold will make it easy to pour the powder back in the container so you can use it again. Then heat the motif with a hot air gun until it melts. If you don't have a hot air gun, you can hold the motif over a toaster or hot plate. Make sure all the embossing powder melts.

STAMPING ON TEXTILES

To stamp on textiles, you have to use ink pads made particularly for textile stamping. The ones we have used are from VersaCraft. These inks can be fixed with an iron and washed with hot water. Printing on light fabrics always gives the best results.

Winter Wreath

Choose different light-colored fabrics, fold them double—right side to right side—and trace five small and five large stars. Mark the opening for turning the shapes right-side out. Sew around the edges. Cut out the stars, leaving narrow seam allowances and notches. Reverse the stars, iron, fill with fiberfil or batting, and sew together the opening. Place the stars on the wreath, alternating small and large, and attach them using a glue gun.

YOU NEED

A wreath made of branches
Various light-colored fabrics
Batting
Glue gun

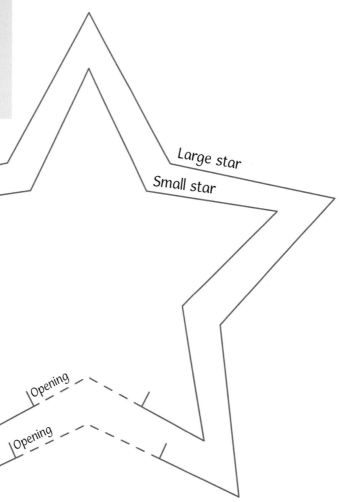

Large star

Small star

Opening

Opening

TIP

This wreath is nice to have outside the whole winter, but at Christmas, you could attach a Merry Christmas sign on it.

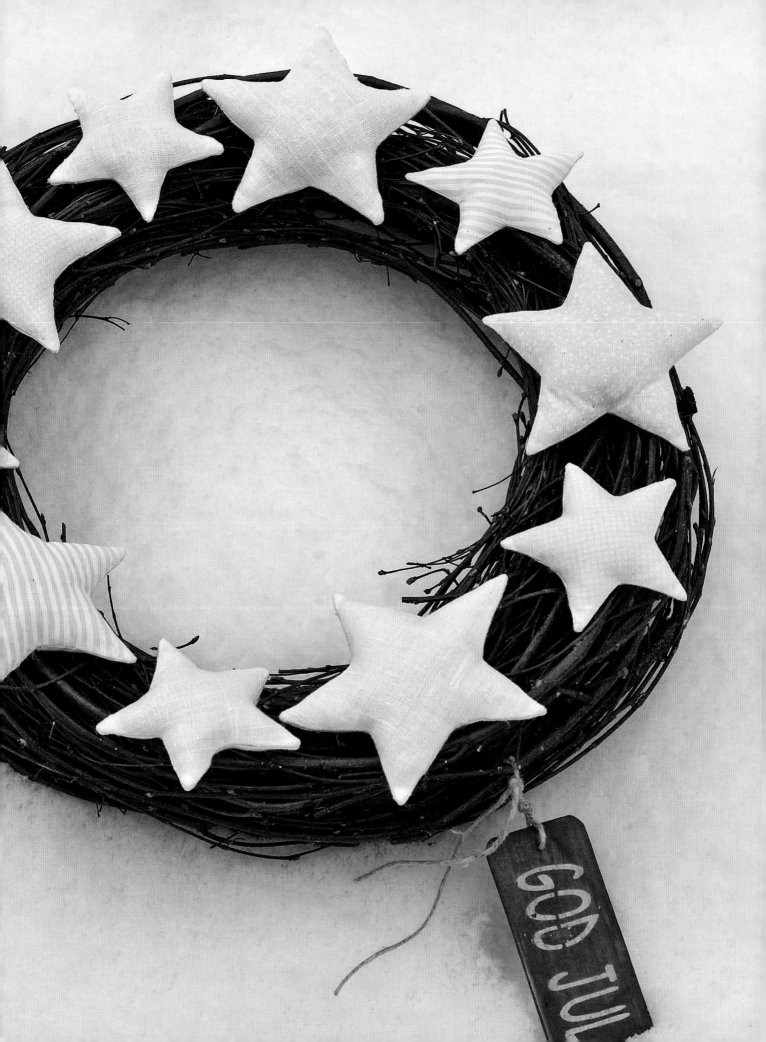

Large Cornucopia

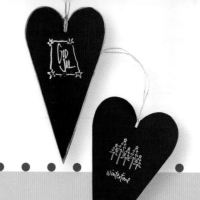

The pattern is on the folded insert at the back of the book.

Trace the patterns for the cornucopia and the fur border. Fold the fabric double and place the edge of the pattern marked "folded edge" against the fold on the fabric. Cut out one from the linen and one from the lining fabric. Cut out the fur border.

HANDLE
Cut a strip of linen 3 by 21½ inches. Also cut a strip of fusible web 1½ by 21½ inches. Iron the fusible web to the middle of the fabric strip. Pull off the paper and fold the edges of the fabric inwards toward the center so the handle is 1½ inches wide, and iron. Sew the velvet ribbon along where the edges of the fabric meet with a seam along each side.

STITCH UP
Fold ³/₄ inch of the bottom part of the fur inwards and sew it in place by hand. Place the wrong side of the fur against the fabric's right side. Place the right side of the handle against the fur where marked; see figure A. Place the lining on top with the wrong side up and sew the parts together along the curved edge on top of the cornucopia. Unfold the pieces, then fold them sideways, right sides together, and sew the side seams; see figure B. Iron the seams. Turn the cornucopia inside out and sew up the opening by hand. Place the lining inside the cornucopia. Iron down the lining on top by the fur border.

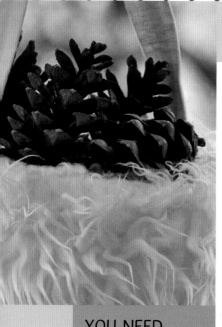

YOU NEED

Linen fabric
Lining
Imitation fur
Fusible web
Velvet ribbon

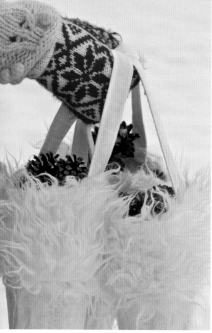

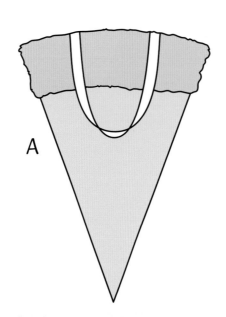

A

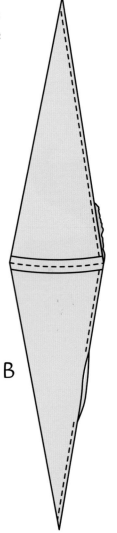

B

You can find a smaller version of the cornucopia on page 70.

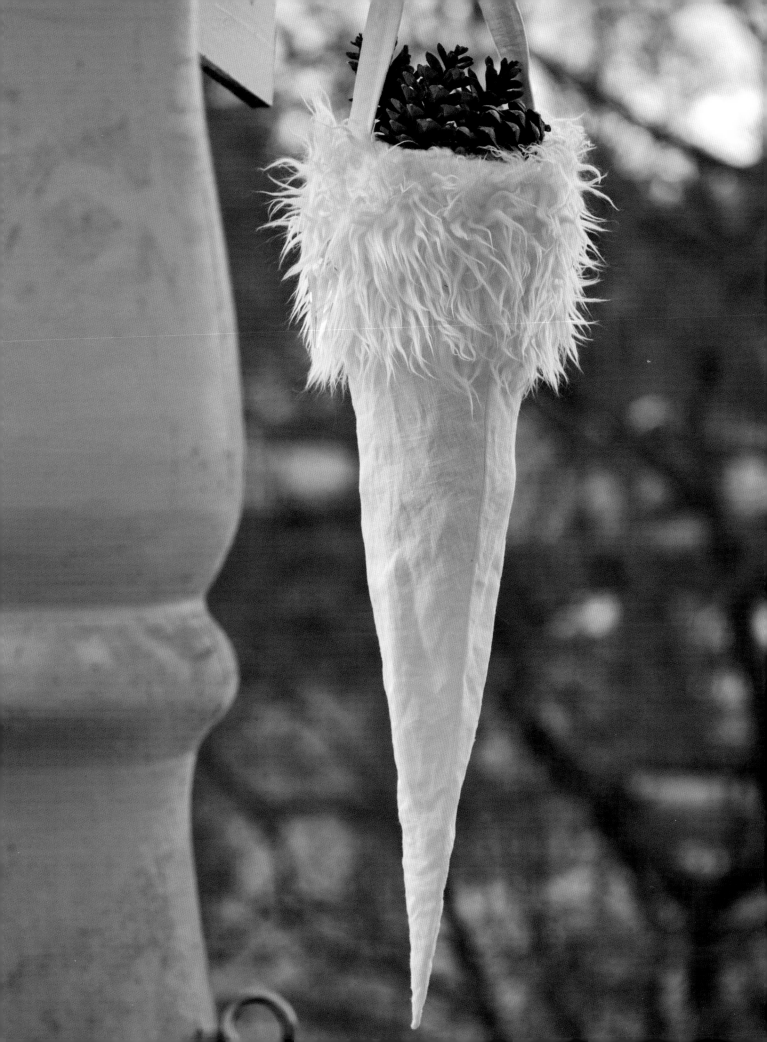

Snow Angel

The pattern is at on the folded insert at the back of the book.

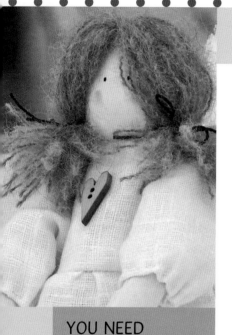

YOU NEED

Cotton fabric for the body
Linen fabric
Imitation fur
Yarn
Embroidery floss
Plastic bean bag pellets
 or rice for filling
Batting

BODY

Fold the fabric for the skin double and trace the body, arms, and legs; see figure A. Cut the bottom from any simple fabric. Sew around the arms and legs. Cut out the parts, remembering to add extra seam allowance near the openings. Trim the seams and make small notches in the seam allowance. Reverse and iron arms and legs, and then stuff with fiberfill. Do not stuff the arms completely so they will be able to move more easily.

Place the arms between the two body parts where marked; see figure B. Sew around the body—remember to leave an opening to turn it right side out. Place the legs inside the body where marked; see figure C. Baste the legs to the body; this will make it easier to sew on the bottom. Put the legs through the reverse opening while sewing on the bottom. Sew the bottom to the body, right side to right side, then turn the body inside out. Fill the bottom of the angel with plastic pellets or rice. This way it will have enough weight to sit on a shelf. Fill the rest of the angel with batting. Stitch up the opening.

DRESS

Fold the fabric in half, pin on the pattern for the bodice, skirt, and sleeve, and cut out the parts. Fold a tuck on each side of the middle on top of the skirt so it will fit with the bodice. Do the same on the other skirt piece and bodice. Stitch up the parts. Place the parts right side to right side and sew up the dress at the shoulders.

Iron the seams. Unfold the parts and sew on the sleeves; see figure D. Place the parts for the dress right side to right side and sew the side seams; see figure E. Turn the dress inside out. Iron the seam allowance around the neck downwards with fusible web. Fold a small hem at the bottoms of the sleeves. Use two strands of embroidery floss and sew the hem with small basting stitches. Put the dress on the angel, tighten the thread around the arms, and tie it off. Fold 1 cm of the bottom of the dress inwards and iron the fold with fusible web.

Cut a strip of fur 1½ by 14½ inches. Place the fur underneath the fold at the bottom of the dress and sew it on with decorative basting stitches (using two strands of embroidery floss). Sew a button on the dress.

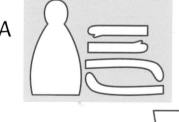

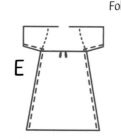

A B

C D E

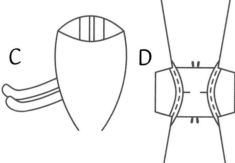

WINGS

Fold the fabric double with the right side inward and place a layer of batting underneath. Trace the pattern, mark the openings, and sew around the outside. Cut out the wings and cut notches in the seam allowance. Turn the wings inside out and iron them. Sew the opening closed and sew the wings onto the doll.

Instructions for the face and hair are on page 22.

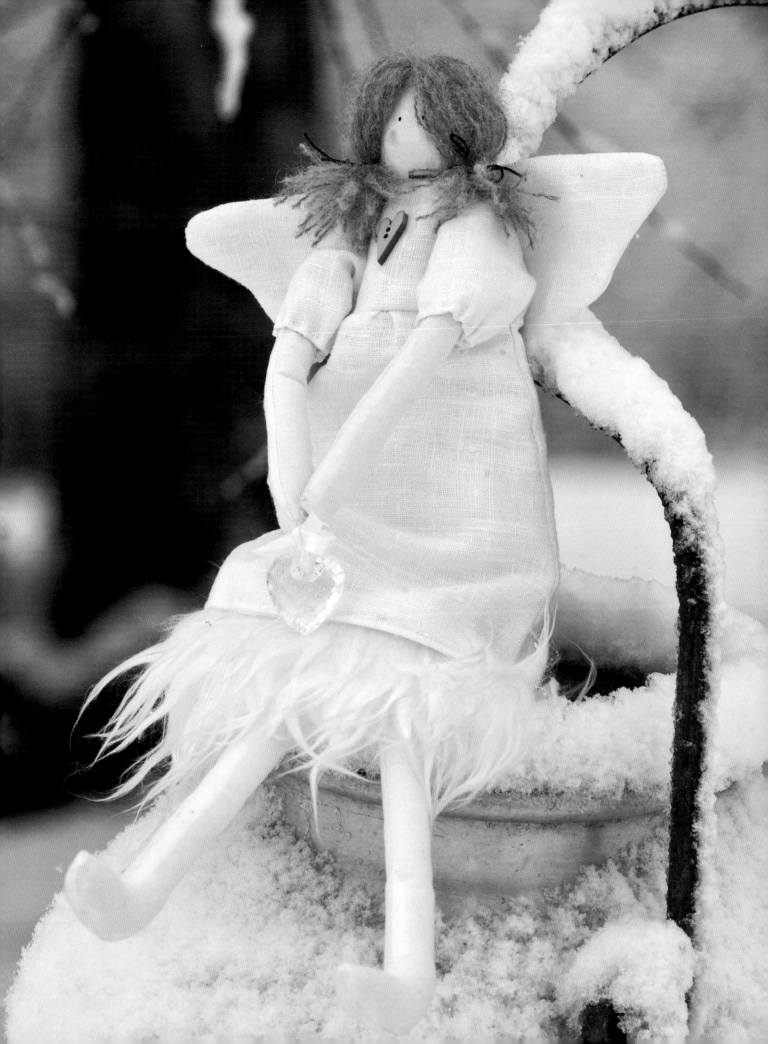

Pattern for Snow Angel

Leg x 4

Body x 2

Arm x 4

Dress x 2

Opening for arm

Opening for arm

Bottom x 1

Reverse opening

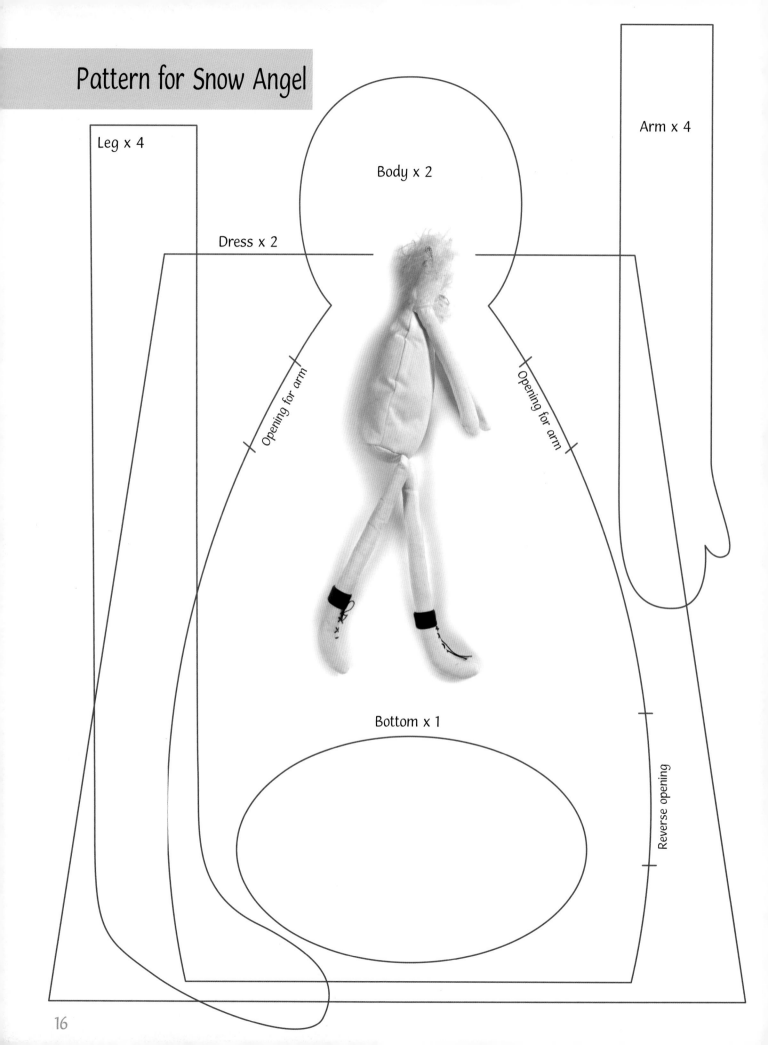

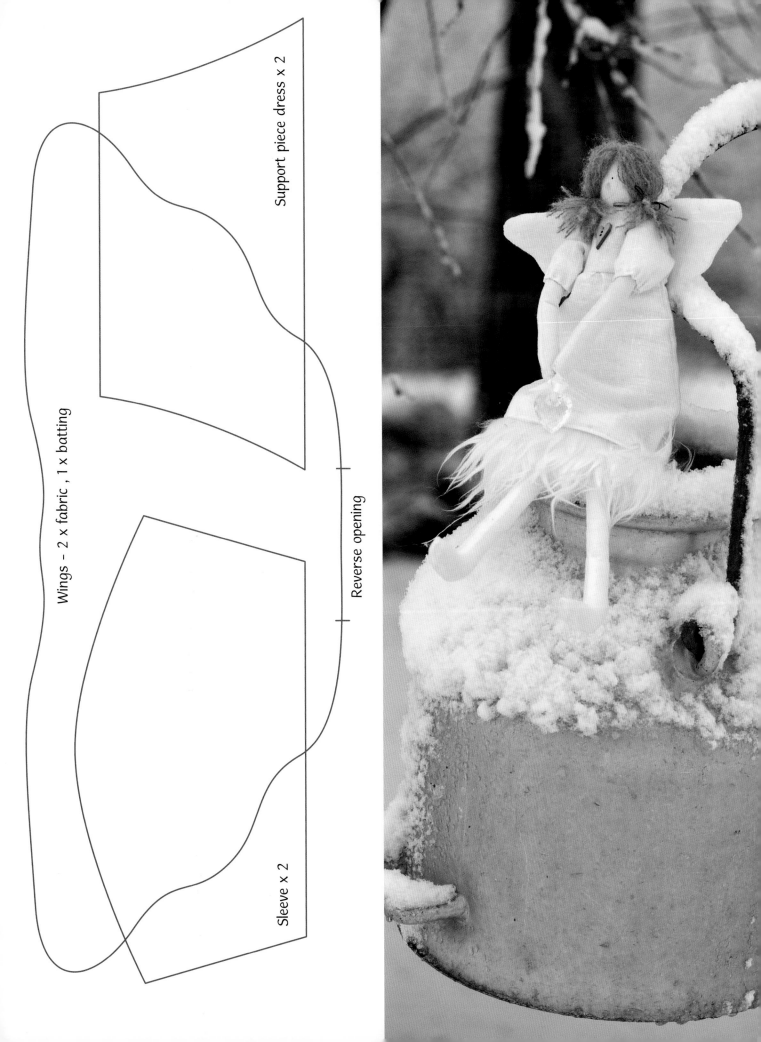

Support piece dress x 2

Wings – 2 x fabric , 1 x batting

Reverse opening

Sleeve x 2

Christmas Mailbox

YOU NEED

Fabric for the mailbox
Fabric for lining
Fabric for the border
Light cotton fabric
Quilt batting
Buttons
Embroidery floss
Rings

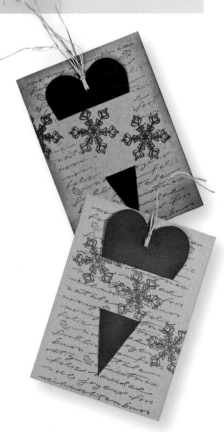

Cut a piece of fabric 11³/₄ by 7³/₄ inches for the front piece, and a piece 6¹/₄ by 7³/₄ for the pocket. Cut pieces of the lining fabric in the same sizes. Cut a light-colored fabric for the embroidered part, 5¹/₂ by 7 inches, and a piece of quilt batting 4¹/₂ by 6¹/₄ inches. Cut two strips of fabric, one 2 by 8¹/₂ inches and one 2 by 45 inches, for the border.

POCKET

Transfer the pattern to the light fabric. Place the quilt batting underneath the marked fabric and stitch on the motif. Fold ¹/₂ inch along the edge inwards and iron. Place the stitched piece of fabric on the fabric that will become the pocket and attach it with pins. Sew the fabric pieces together with decorative basting stitches, about ¹/₈ inch from the edge of the embroidered piece. Sew a button to each of the four corners of the light fabric. Place the pocket piece on top of the lining piece and baste the pieces together. Sew a border on the top edge of the pocket piece.

Place the front piece and the lining together, wrong side to wrong side. Place the pocket piece on top of the other fabric pieces, make sure every layer is straight, attach the pieces together with pins, and then baste the pieces together. Sew a border around the whole piece. Sew two rings to the back of the Christmas mailbox as hangers. Also, sew a few buttons to the top of the mailbox for decorations.

You can also attach a pinecone and a fabric star as additional decorations.

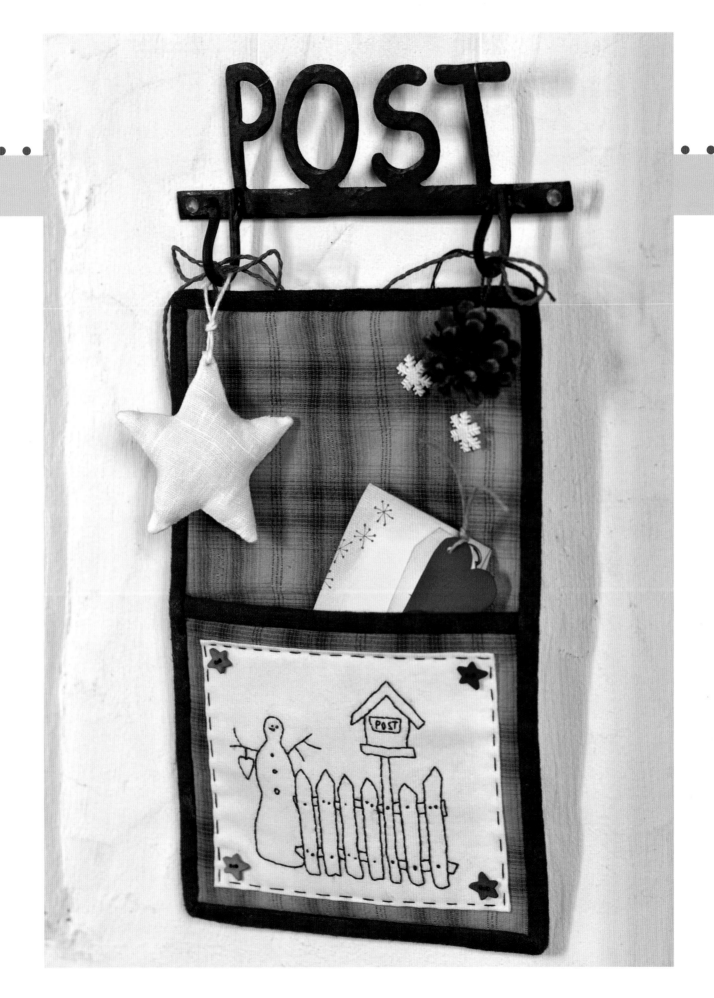

Welcome Angel

The pattern is on the folded insert at the back of the book.

YOU NEED

Light-colored fabric for
 head and feet
Fabric for body
 and arms
Fabric for the tree
Felt for shoes and scarf
Plastic bean bag pellets
 or rice for filling
Fiberfill
Imitation fur
Twigs
Button
Yarn
Plywood
Glue gun

BODY

Cut the bottom from a light-colored fabric. Cut a piece of fabric 6 1/2 by 12 1/2 inches for the body, a piece of light-colored fabric 3 1/4 by 12 1/2 inches for the head, and a piece of light-colored fabric 4 by 12 1/2 inches for the bottom part of the body. Sew the pieces together as shown in figure A. Iron the seams. Fold the piece in half, right side to right side. Trace the pattern for the body onto the cloth so the borders between the fabrics are near the markings on the pattern; see figure B. Mark the opening. Sew around the body except the bottom. Cut out and cut notches in the seam allowance.

FEET

Fold the felt in half and cut parts for two shoes. Cut two pieces 3 1/4 by 11 3/4 inches from the same light-colored fabric you used for the body. Place the two parts of the shoe together and sew a seam on 5 cm of the edge; see figure C. Do the same with the other shoe. Unfold the shoe piece and sew it to the light leg fabric; see figure D. Fold the piece together and continue the seam around the shoe and up along the leg. Reverse, iron, and stuff the feet.

Place the feet inside the body where marked; see figure E. Attach them with basting stitches so the feet are placed correctly when you sew on the bottom. Put the legs through the opening while you sew on the bottom. Sew on the bottom, reverse the figure, and iron the body. Fill the bottom with plastic pellets or rice and the rest of the body with fiberfil. Close the opening.

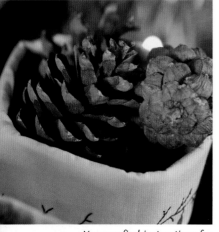

You can find instructions for making the bag pictured with the angel on page 25.

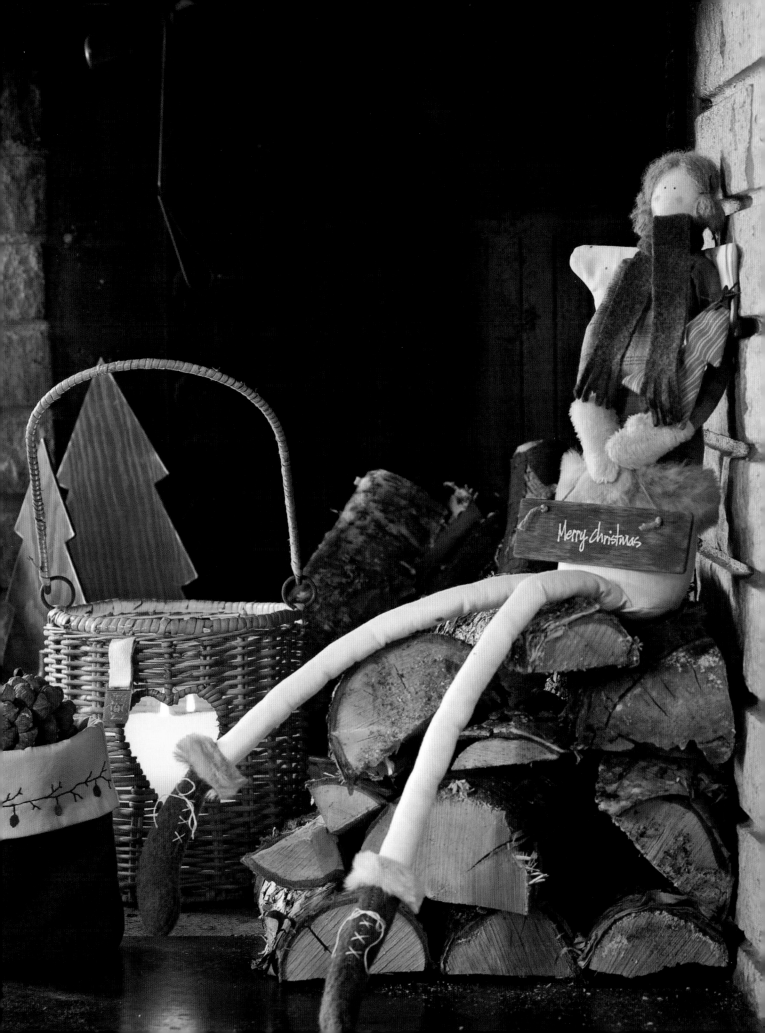

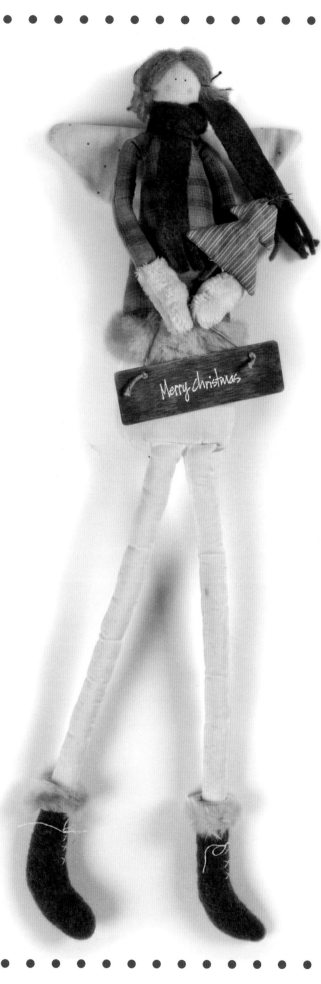

ARMS

Cut a piece of fabric for the mittens 3 by 9 3/4 inches and a piece of the body fabric 7 by 9 3/4 inches and sew them together. Lay them flat and iron the seam allowance. Fold the combined piece in half, right side to right side. Trace the pattern for the hands so the border between the fabrics is at the markings on the pattern; see figure F. Sew around the hands and arms and cut them out. Reverse, iron, and stuff the arms. Fold the seam allowance on top of the arm inwards and sew the arms onto the body by hand.

F G

FACE/HAIR

Cut pieces of yarn 5 1/2 inches long. Place the yarn on the head and baste from the forehead and backwards. Make the yarn into pigtails. Use a black waterproof ink pen to make the eyes (make sure it's not too thick). Use a brush and a pink stamp pad to make the rosy cheeks.

WINGS

Place the fabric, folded in half with the right side inwards, on a layer of batting. Trace the pattern, mark the opening, and sew around the edge. Cut out the wings, and cut notches in the seam allowance. Reverse and iron the wings. Close the opening and sew the wings to the figure.

SIGN

Sand, stain, and drill holes in a piece of plywood measuring 1 1/2 by 5 inches. Stamp on the desired text. Thread a small rope through the holes and make knots on the front side of the sign. (You can also buy a ready-made sign if you wish.)

Sew the tree as described on page 63. Make the scarf from felt: cut a piece of felt 1 by 20 inches and cut fringes at the ends. Felt does not fray, so you don't need to hem it. Cut a strip of imitation fur 1 inch wide to go around the body and two strips 3/4 inch wide to go around the legs. Glue or baste the widest strip over the seam between fabrics on the body. The other strips should be placed over the seam between the fabrics on the leg. Sew a few crosses on the shoes for laces and make a bow; see figure G. Glue the hands, the sign's rope, and the tree to the stomach.

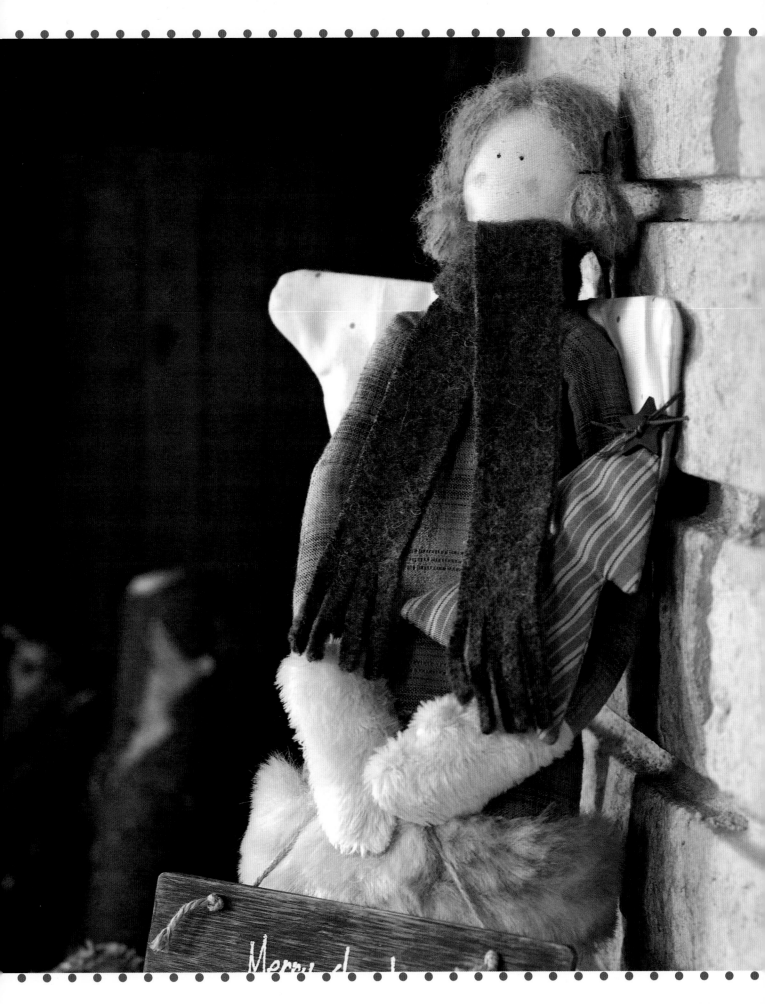

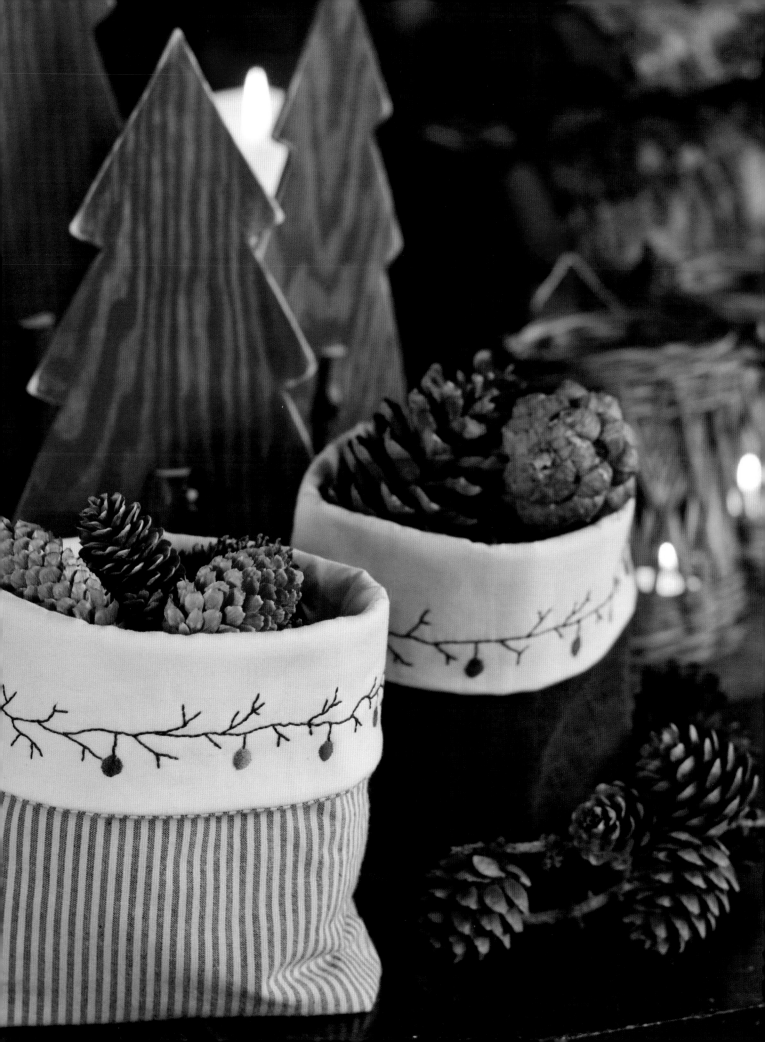

Folded Bags

	Total cutting measures	Cropped corners
Small bag	9 x 20 in.	$1^{1}/_{4}$ in.
Large bag	$11^{1}/_{2}$ x $24^{3}/_{4}$ in.	2 x $2^{1}/_{2}$ in.

YOU NEED

Cotton fabric
Fabric for the lining
Quilt batting

Choose desired size for the bag and cut one piece of outer fabric, one piece of the lining fabric, and one piece of the quilt batting. Trace the motif onto the lining fabric. Make sure you place the border the right way up; see figure A. Place the border 1 inch from the running edge. Place the quilt batting underneath the lining fabric and embroider the border. Place the parts right side to right side and sew them together at the short sides; see figure B.

Place the pieces of fabric so the seams are right on top of each other and cut a notch at each corner; see figure C. The longer measurement for the corner notch is measured from the long side. Sew the side seams, remembering to leave an opening in the lining for turning the bag inside out; see figure D. Fold the corners and sew the cross seam; see figure E. Do the same at all four corners. Turn the bag inside out and iron the border. Fold a border 2 inches wide down around the top of the bag.

A B C D E

25

Soft Hearts

The pattern is on the folded insert at the back of the book.

Hearts are a wonderful motif for Christmas. We make these big hearts for hanging on the wall, by the fireplace, or on a door handle. Some of the hearts are made with a little pocket, and you can put little notes with Christmas greetings in them. Or you can embroider words or a poem on a patch and sew it on to the heart. The hearts have different fabric on the front side and back side. The possibilities are many.

Cut a heart in a piece of fabric for the front piece and one for the back piece. Make a patch for a pocket or a patch with text.

YOU NEED

Cotton fabric
Lining fabric
Ribbon
Batting
Fiberfill
Embroidery thread

TIP

For an extra touch, sew a matching piece of ribbon like a tag.

WITH A POCKET

Cut a patch for the pocket 4 $\frac{1}{2}$ by 5 $\frac{1}{2}$ inches. Fold the edges $\frac{1}{2}$ inch inwards at the sides and bottom and iron. Fold the top edge inward 1 inch and iron. Transfer the pattern to the patch, placing the text at the center of the patch. Embroider the text. Sew basting stitches $\frac{1}{8}$ inch from the edge around the patch for decoration. Baste another seam $\frac{3}{4}$ inch from the top edge. Place the pocket in the middle of the front piece and sew it to the heart, putting the seam right along the edge.

WITH TEXT

Cut a patch 5 $\frac{1}{4}$ by 5 $\frac{1}{2}$ inches. Cut a piece of batting 4 $\frac{1}{2}$ by 4 $\frac{3}{4}$ inches. Transfer the pattern to the patch. Place the batting underneath the fabric and embroider the text. Fold all the sides inwards by $\frac{1}{2}$ inch and iron. Embroider basting stitches for decoration around the patch, 1 inch from the edge. Place the patch on the front side of the heart and sew it on, putting the seam right along the edge.

Place the parts of the heart right side to right side. Fold a ribbon in half and place it between the layers right by the edge, 6 inches from the tip of the heart, and sew around the entire outside of the heart. Remember to leave an opening. Turn the heart inside out, iron, and stuff with fiberfill. Close the opening. Attach a ribbon or small rope for a hanger.

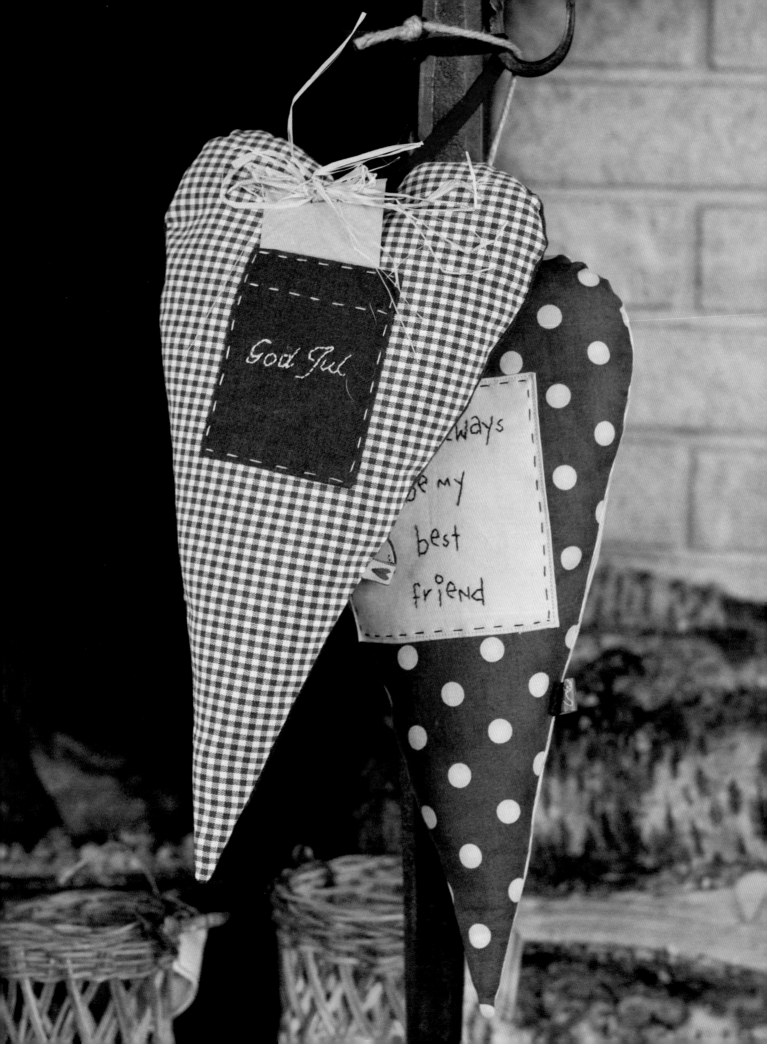

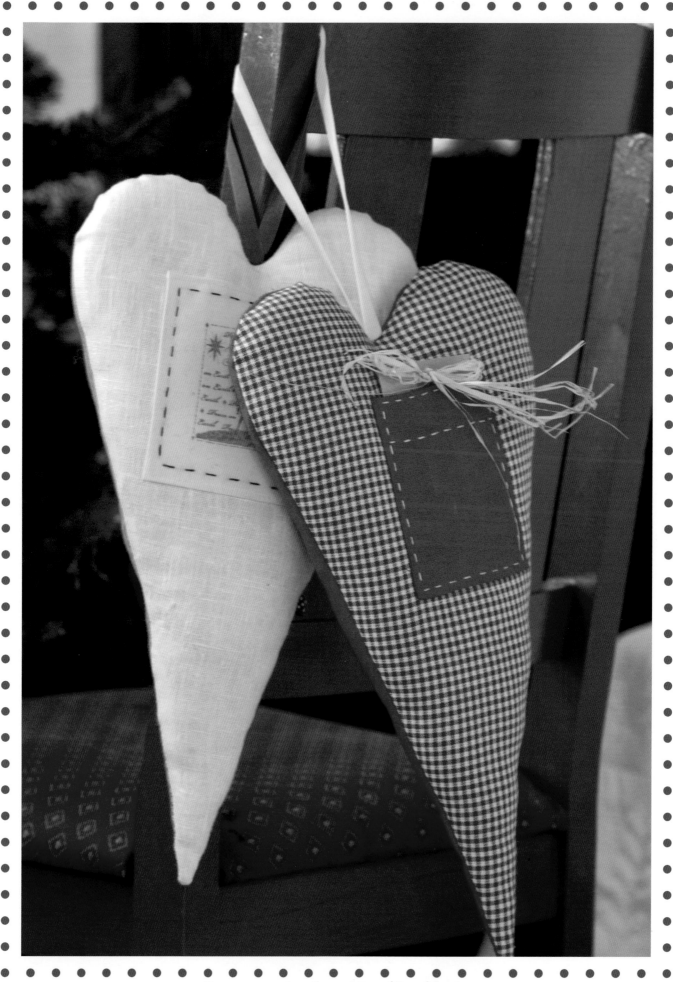

Here you can see two other variations of the soft hearts.

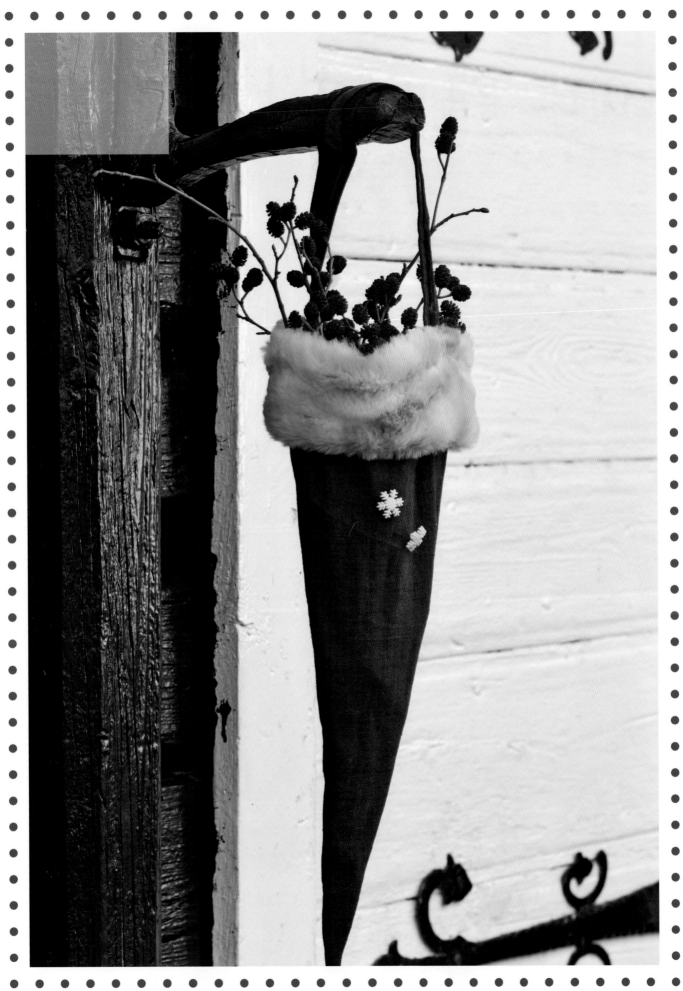

This cornucopia is sewn the same way as the winter white cornucopias on page 71.
We have sewn on two snowflake buttons for decoration.

Large Plywood Heart

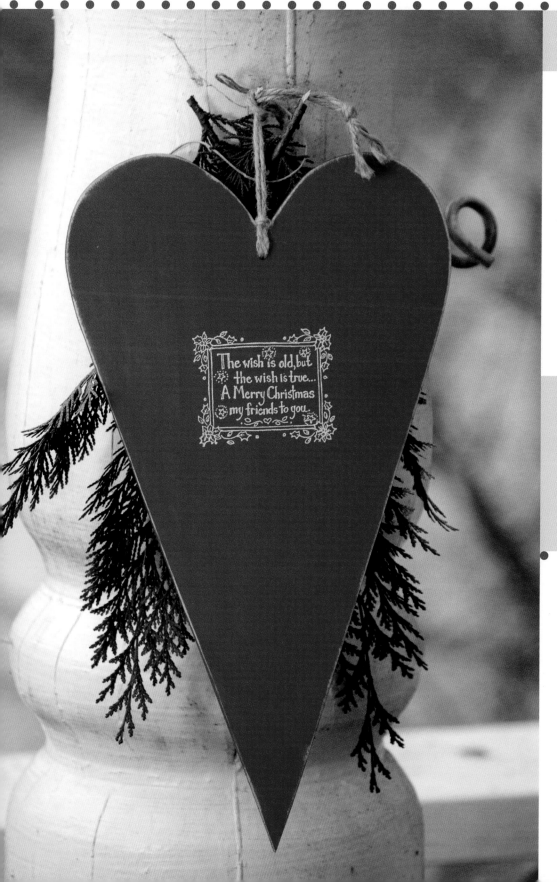

The pattern is on the folded insert at the back of the book.

Trace the heart pattern on a piece of plywood. Cut out the pieces. Make a 4 mm hole. Sand the edges with sandpaper. Paint the heart with craft paint. Sand the edges after the paint has dried to get a worn look. Emboss or stamp on the desired motif. Attach a small rope or string for a hanger.

YOU NEED

Plywood, 4 mm
Craft paint
Stamp
Embossing supplies
String

The wish is old, but the wish is true...
A Merry Christmas my friends to you.

Heart Pillowcase

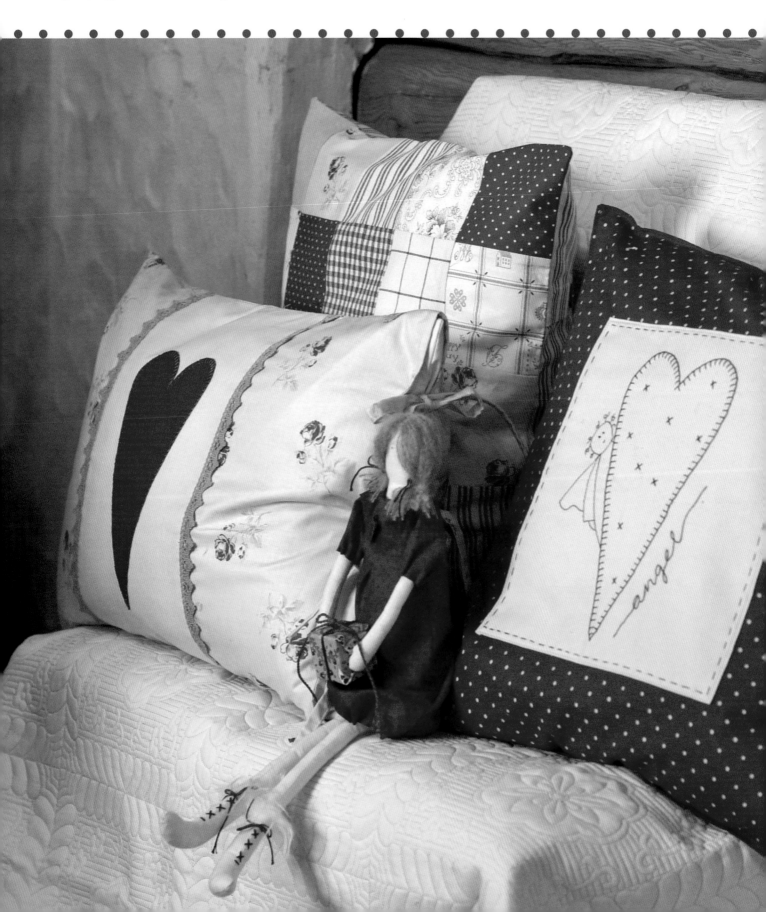

Heart Pillowcase

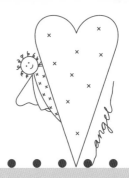

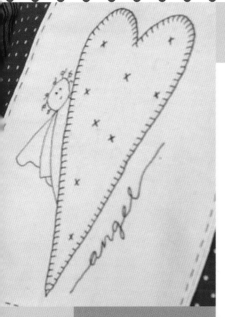

YOU NEED

Light-colored fabric
Fabric
Embroidery thread
Buttons
$19^{1}/_{2}$ x $19^{1}/_{2}$ in. pillow

The pattern is on the folded insert at the back of the book.

Cut a piece of light-colored fabric $11^{1}/_{4}$ by $11^{1}/_{4}$ inches, a piece of quilt batting $10^{1}/_{2}$ by $10^{1}/_{2}$ inches, a piece of fabric for the front of the pillowcase 20 by 20 inches, and one piece 10 by 20 inches and another $16^{1}/_{4}$ by 20 inches for the back of the pillowcase.

DECORATIVE PATCH
Transfer the pattern to the patch. Place the batting right underneath and baste the pieces together so they will stay in place. Embroider the motif: we used blanket stitches around the heart and stem stitches for the angel and text. Fold the edge inwards $1/_{2}$ inch all around and iron it down. Sew long basting stitches as a decorative seam around the patch, about $1/_{8}$ inch from the edge. Place the patch in the middle of the front piece. Sew the patch to the fabric right along the edge.

BACK PIECE
Fold over and iron down 2 inches on one of the long sides of the fabric. Fold the running edge inwards again by $1/_{2}$ inch and iron. Sew the hem right along the edge; see figure A. Do the same on the other half.

A

B

Lay out the front piece with the right side upwards. Place the smaller back piece right side to right side on top of the front piece, and then do the same with the larger piece. The back pieces should now overlap each other by $1^{1}/_{2}$ inches. Sew together all the pieces around the whole pillowcase. Turn inside out and iron. Sew a decorative seam $1/_{8}$ inch from the edge around the whole pillowcase. Make four button holes in the edge the upper back piece; see figure B. Sew buttons onto the other back piece.

Doll with Present

. . . do not open before Christmas Day!

This doll is sewn the same way as the snow angel on page 14, but without the fur on the dress. There should be a hem at the dress like in the sleeves. The Christmas doll has "shoes" on her feet and a present in her hands.

SHOES
Make the shoes by sewing a few cross stitches on the doll's feet for shoe laces, using the ends of the embroidery floss to tie a bow. Cut a strip of imitation fur and glue it around the doll's calf to divide the leg and shoe.

Make a small present and glue it to the doll's hands.

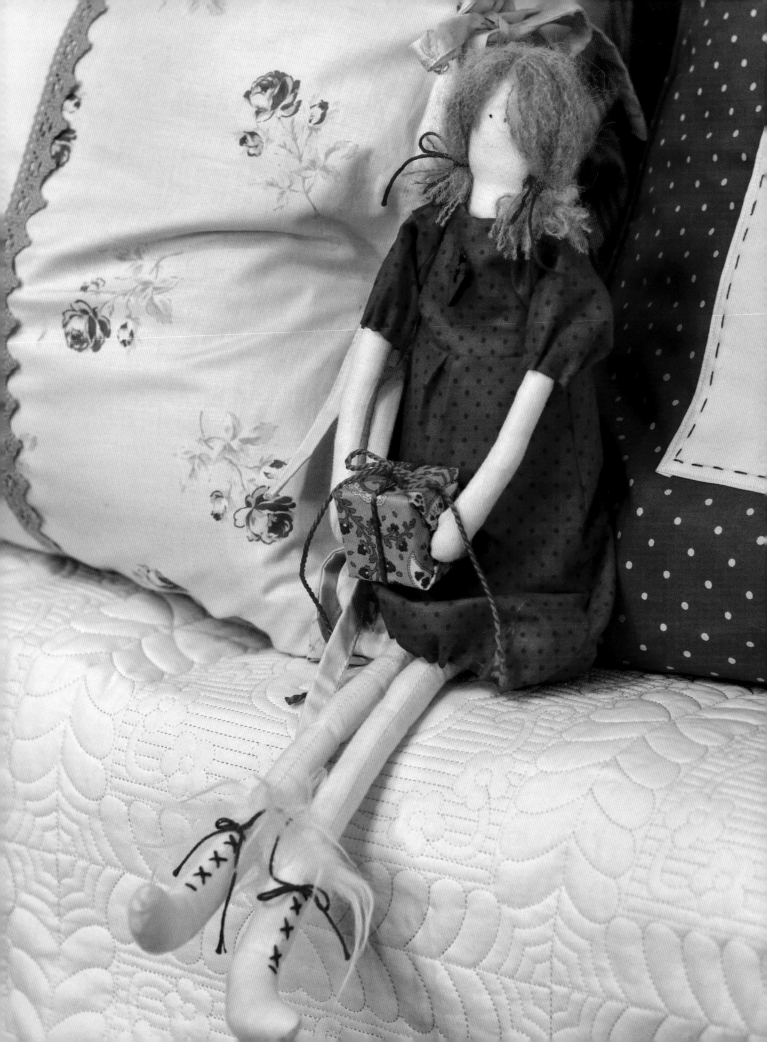

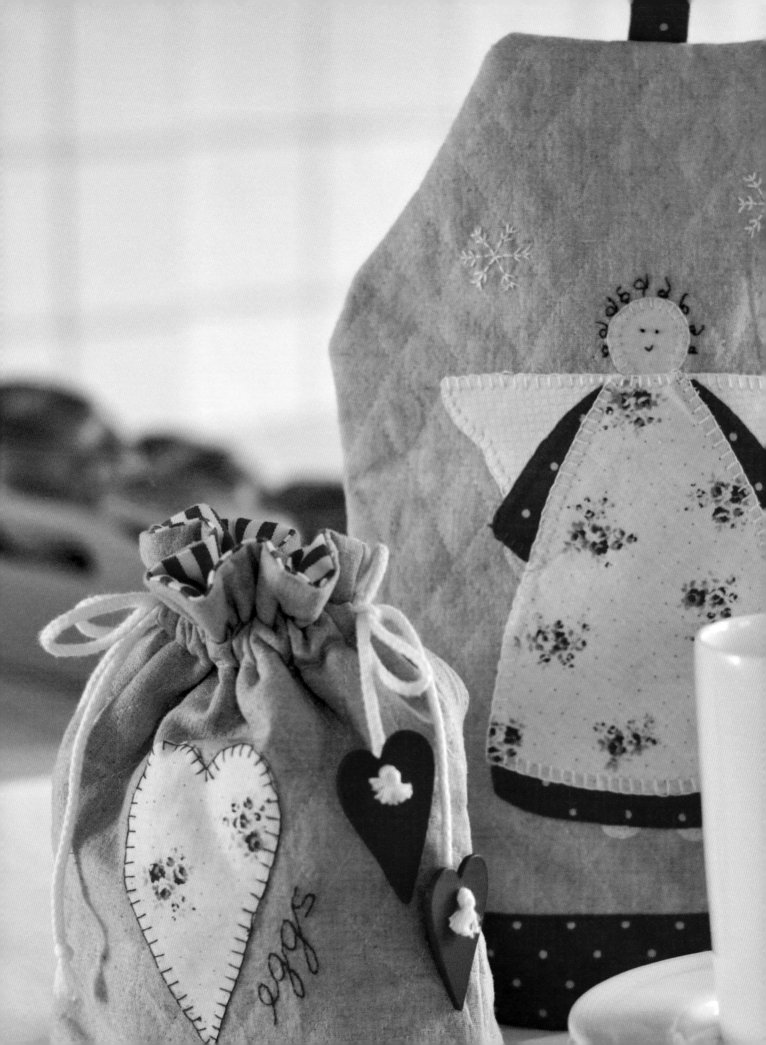

Coffee Warmer

The pattern is on the folded insert at the back of the book.

This coffee warmer fits a small French press. You can make it smaller or larger depending on the size of your press or coffe pot.

Cut the pattern from two pieces of lining fabric. Cut a strip of fabric for the bottom edge 6 1/4 by 20 inches.

Draw the pattern for the angel on fusible web. Place the angel 7 cm from the top and in the middle of the fabric piece. Iron the pieces together. Sew around the parts with blanket stitches. Embroider two snowflakes above the angel.

HANGER
Cut a piece of fabric 2 by 2 3/4 inches. Use the same fabric as you used for the border at the bottom of the coffee warmer. Fold the strip in half with the right side inwards and sew a seam along the long side. Iron the seam and turn inside out. Make sure the seam is in the middle and then iron.

STITCH UP
Place the pieces of fabric right side to right side. Fold the hanger in half and place it in between layers on top of the coffee warmer. Place the lining right side to right side on top of the fabric pieces. Sew all the parts together. Turn the warmer inside out and iron. The seam allowances are now hidden inside the warmer.

BORDER
Fold the fabric strip for the border in half with the wrong side inwards and iron. Fold out and fold each edge inwards toward the fold in the middle—see figure A—and then iron. Open the folds again and fold the fabric width-wise, right side to right side, and sew the side seam; see figure B. Iron the seam. Put the border on the outside of the coffee warmer, right side to right side. Sew the border to the fabric along the top fold line; see figure C. Fold the border around to the back and stitch up by hand.

YOU NEED

Padded linen fabric
Fabric for angel
Embroidery thread
Lining

A

B

C

35

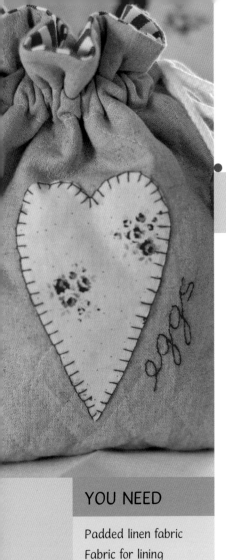

Egg Warmer Bag

Keep boiled eggs in a padded bag and they will stay warm through the whole meal.

Cut a piece of linen and a piece of the lining fabric. The parts should be 20 1/4 inches tall and 9 1/2 inches wide. Trace the heart on fusible web. Place the motif in the middle of the piece, 3 3/4 inches from the top edge. Iron the heart to the fabric and embroider with blanket stitches.

Fold the linen fabric in half with the right side inwards and sew the side seams. Leave an opening 1/2 inch wide for a casing for the drawstring on each side of the bag, 1 1/2 inches from the top. Iron the seams. Sew the lining the same way, remembering to leave a reverse opening in one of the side seams. Iron the seams. Sew the corners the same way as in the cookie cutter bag on page 80. Turn the lining inside out and place it inside the padded fabric piece with the right sides facing each other. Sew the pieces together at the top of the bag. Turn inside out and iron. Place the lining inside the bag. Sew a seam on either side of the casing, making sure the opening you left is between these seams. Cut two strings 25 inches long. Thread the strings through the openings on each side so you will be able to close the bag; see figure A. You can tie hearts to the ends of the strings if you want.

Add some fiberfill at the bottom of the bag to keep the eggs warm.

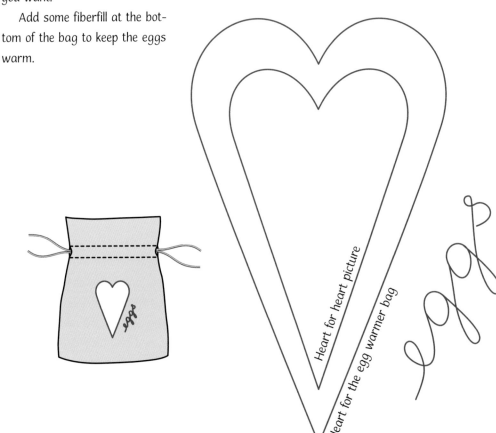

Heart for heart picture

Heart for the egg warmer bag

eggs

Heart Picture

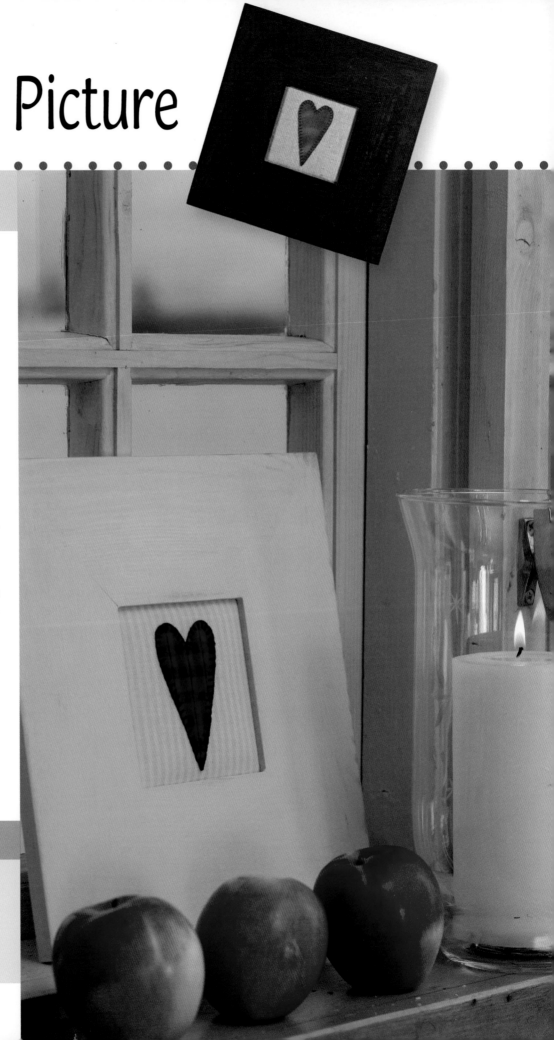

Cut a piece of fabric 1$\frac{1}{2}$ inches larger than the length and width of the frame opening. Trace the heart on fusible web. Iron the heart to the middle of the front side of the fabric. Sew blanket stitches around the heart. Cut a piece of batting and a piece of cardboard that match the size of the opening on the back side of the frame. Iron the batting to the middle of the back side of the fabric. Place the fabric around the cardboard and put it in the frame. Fold down the fabric edge and put the back of the frame back on.

YOU NEED

Frame
Cotton fabric
Iron-on batting
Embroidery thread
Cardboard

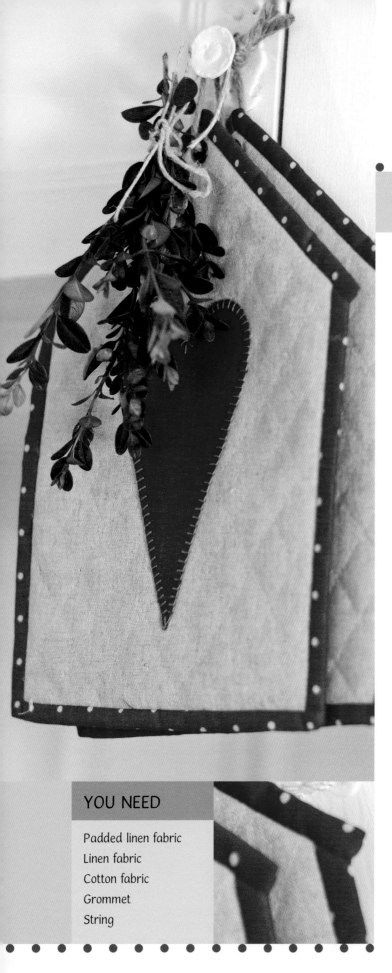

Pot Holder

The pattern is on the folded insert at the back of the book.

Trace the pattern onto the padded linen and cut four pieces—two fronts, two backs. Trace two hearts in red linen and attach them to the fabric with fusible web. Sew with blanket stitches around the edges of the hearts. Place the two parts of each pot holder together with the right sides out. Stitch up the pieces with basting stitches.

BORDER

Cut two cotton fabric strips 2 1/4 by 25 1/2 inches for the sides and bottom, and two strips 2 1/4 by 13 1/2 inches for the "roof." Fold the strips in half with the right side outwards and iron. Attach the border around the sides and bottom as described on page 7, starting at the top right side. Cut the extra fabric before you start working on the top; see figure A. Sew a border on the "roof." Make sure there is enough fabric on the ends to fold a bit inwards.

We used a string to hang the pot holders. We attached a grommet on top of the pot holder and threaded the string through the hole.

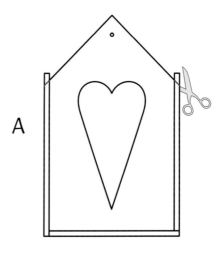

A

YOU NEED

Padded linen fabric
Linen fabric
Cotton fabric
Grommet
String

Kitchen Towel

The pattern is on the folded insert at the back of the book.

Cut a piece of cotton fabric 25 1/2 by 19 1/2 inches. Place the fabric over the pattern, with the pattern 4 1/2 inches from the bottom edge and the middle kringle in the middle of the towel. Trace the pattern. Embroider with stem stitches. Fold both of the short sides inwards and sew the hem. Place the lace over the bottom hem and attach the lace with running stitches. Fold the long sides inwards and sew the hem.

YOU NEED

White cotton fabric
Embroidery thread
Lace

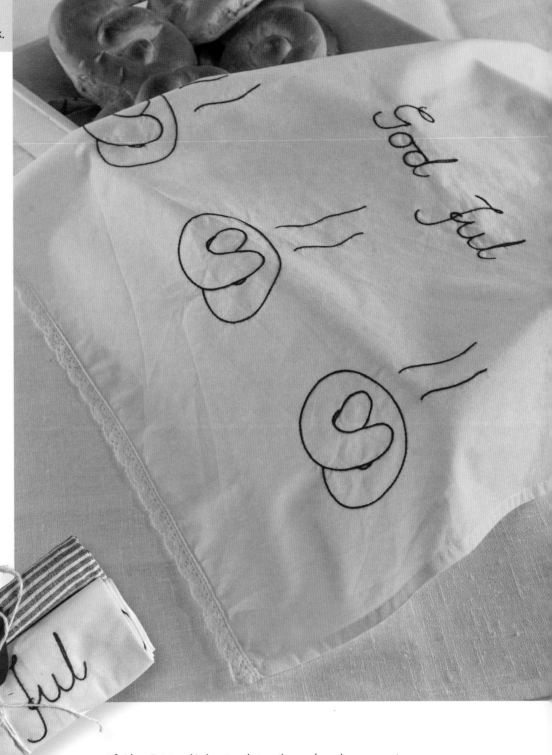

Gift idea: Put two kitchen towels together and you have a great gift. A red wooden heart will add an extra touch.

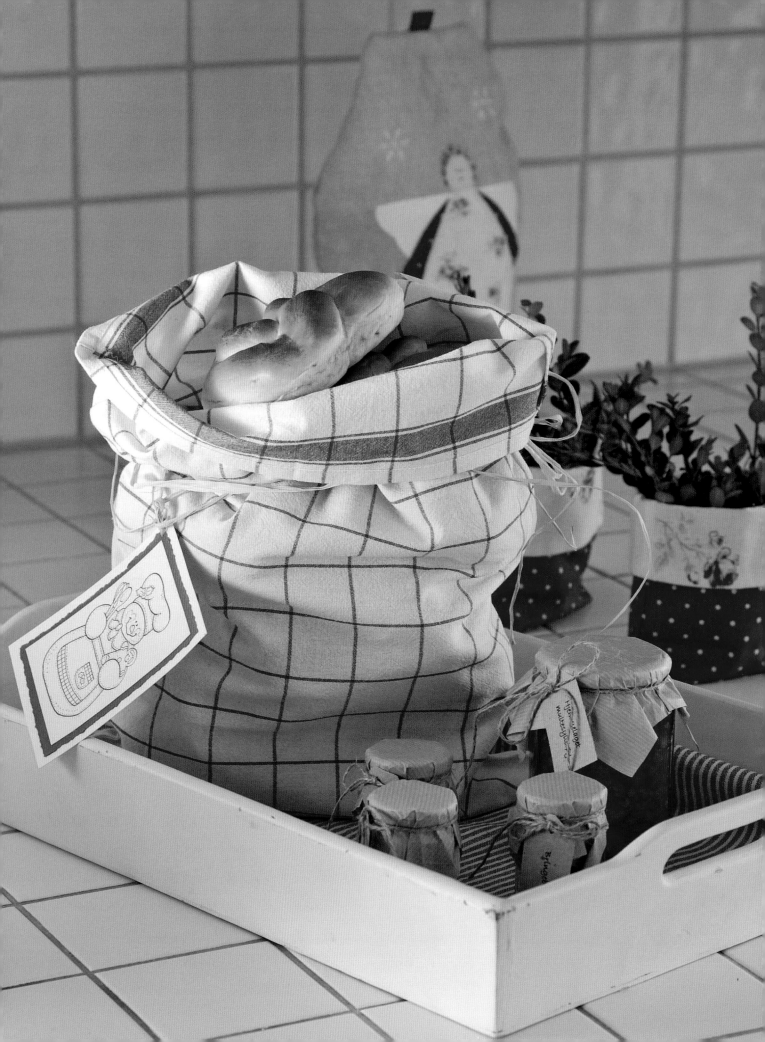

Christmas Kringle Bag

YOU NEED

Kitchen towel or check-ered cotton fabric

TIP

There are many nice kitchen towels in dif-ferent sizes. Fold the towel in half, right side to right side, and stitch up the sides and bot-tom. Tie the bag with rafia and attach a nice little Christmas card.

Cut a piece of fabric 18 $^3/_4$ by 25 inches. Fold the fabric in half with the right side inwards. Stitch up the side and bottom of the bag. Sew zigzag stitches outside the seam so the fabric won't unravel. Fold a hem at the top of the bag. Sew running stitches around the edge.

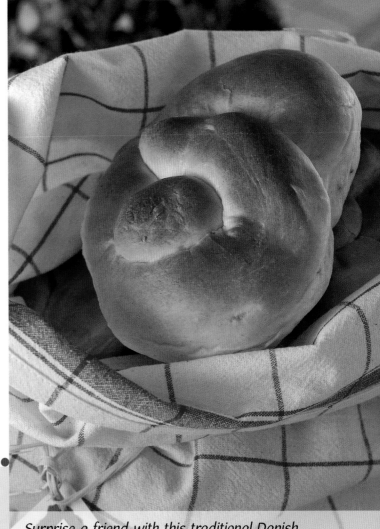

Surprise a friend with this traditional Danish Christmas pastry!

Kringle

$^1/_3$ c margarine
2 c milk
1 package or 1 Tbsp dry yeast
1 tsp cardamom

2 tsp anise
A little salt
$^1/_2$ c sugar
About 6 c flour

Melt the margarine. Add milk and heat the mixture until it has the same tem-perature as your finger.

Add the yeast and stir until it is dissolved. Add sugar, cardamom, anise, salt, and then flour. Stir the dough until it pulls back from the sides of the bowl. Cover the dough and let it rise in a warm place until it has doubled in size, about 45 minutes.

When the dough is ready, place it on a table and cut it into 16 pieces. Roll each piece into a long sausage shape about 18 inches long, and then form it into a kringle, folding the dough like a pretzel. Place the kringles on a baking tray and put them in a warm place so they can rise again. Bake the krin-gles at 400 degrees F for about 10 minutes until they have a golden color. Brush the kringles with milk as soon as you take them out of the oven.

Angel Picture

The pattern is on the folded insert at the back of the book.

Trace the pattern onto tracing paper. Cut a piece of light-colored fabric 10 $\frac{1}{4}$ by 7 $\frac{1}{2}$ inches. There are 28 patches in different fabrics as a frame around the picture. Cut patches 2 by 2 inches. Stitch up seven patches into one long strip; do this four times. Iron all seam allowances in the same direction. Be accurate with the seam allowance; it should be $\frac{1}{4}$ inch. The patches are not meant to be arranged in any specific pattern. Sew two of the strips to the long sides of the light fabric and iron the seams in toward the back side of the light fabric. Sew the other two strips to the short sides and iron the seams the same way. Place the wax paper with the traced pattern in the middle underneath the light fabric and transfer the pattern.

Place the picture on the quilt batting, cut the quilt batting to the same size, and baste the layers together. Embroider the motif. Place the picture and batting on the backing fabric and cut the backing so it's just as big as the front piece. Cut a strip of fabric 2 by 48 $\frac{3}{4}$ inches for the border. Fold the strip in half and iron with the right side out. Sew the border on as described on page 7.

Sew a seam of decorative basting stitches 1 $\frac{1}{2}$ inches inside the edge of the light-colored fabric.

YOU NEED

Light-colored fabric
Quilt batting
Various cotton fabrics
Backing fabric
Embroidery thread
Button

Wooden Bead Hearts

Small heart

String 37 wooden beads with a diameter of 15 mm on a strong wire.
Bend the wire slightly at the end so the beads don't slide off. Cut a strip of fabric 2 $\frac{1}{2}$ by 58 $\frac{1}{2}$ inches. Fold it in half and sew up the long side and one of the short sides. Reverse the strip and iron. Thread the wire with the beads through the fabric tube. Do not cut off any extra fabric yet. Wrap two strands of embroidery thread between the beads, tighten, and tie. Shape the wire into a heart. Cut off the extra fabric strip 1 inch from the last bead. Fold the cut edges inwards and baste the ends together. Now adjust the wire to get the heart shape you want.

Large heart

Use 39 beads with a diameter of 20 mm. The fabric strip should be 3 $\frac{1}{4}$ by 58 $\frac{1}{2}$ inches. Make the large heart the same way as the small heart.

YOU NEED

Fabric
Wooden beads
Strong steel wire
Embroidery thread

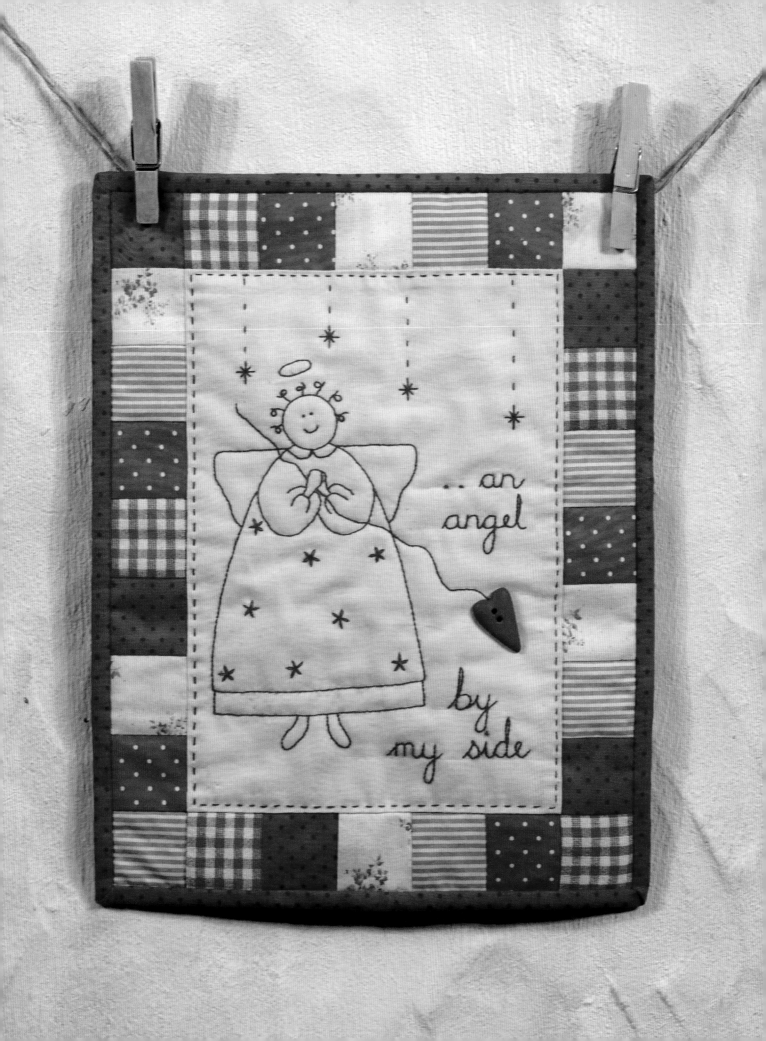

...an angel
by my side

Candy Canes

The pattern is on the folded insert at the back of the book.

Candy bags

Cut a piece of cotton fabric and a piece of the lining fabric, both 6 ¾ by 5 ½ inches. Sew the bag the same way as folded bag on page 25, but without the embroidery. The small bag does not need a layer of batting.

YOU NEED

For the bags:
 Cotton fabric
 Lining fabric

For the candy canes:
 Striped cotton fabric
 Fiberfill

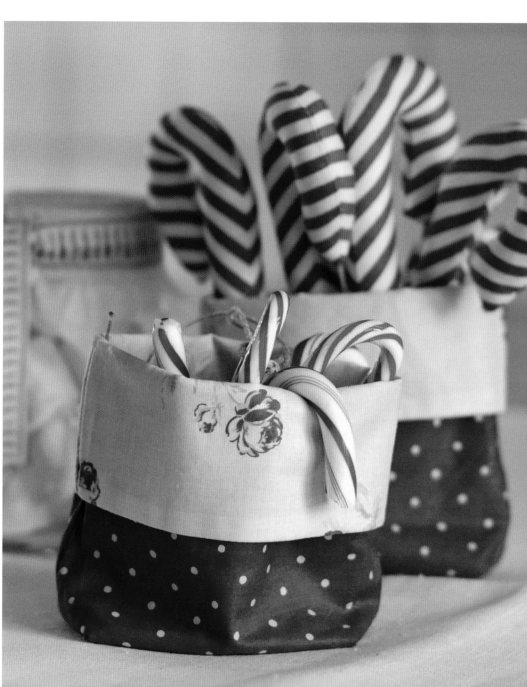

Fabric candy canes

The candy canes are sewn in three different sizes. A striped fabric is a good choice for the candy canes.

Trace the pattern for the desired size and mark the opening for turning the project inside out. Fold the fabric in half and place it so the stripes go diagonally (the thread direction is marked on the pattern). If you are making more than one candy cane, it is a good idea to trace all of them before you start sewing. Sew along the traced line. Cut the pieces out. Cut notches in the seam allowance where the candy cane bends. Turn inside out and iron. Stuff the cane with fiberfill and stitch up the opening.

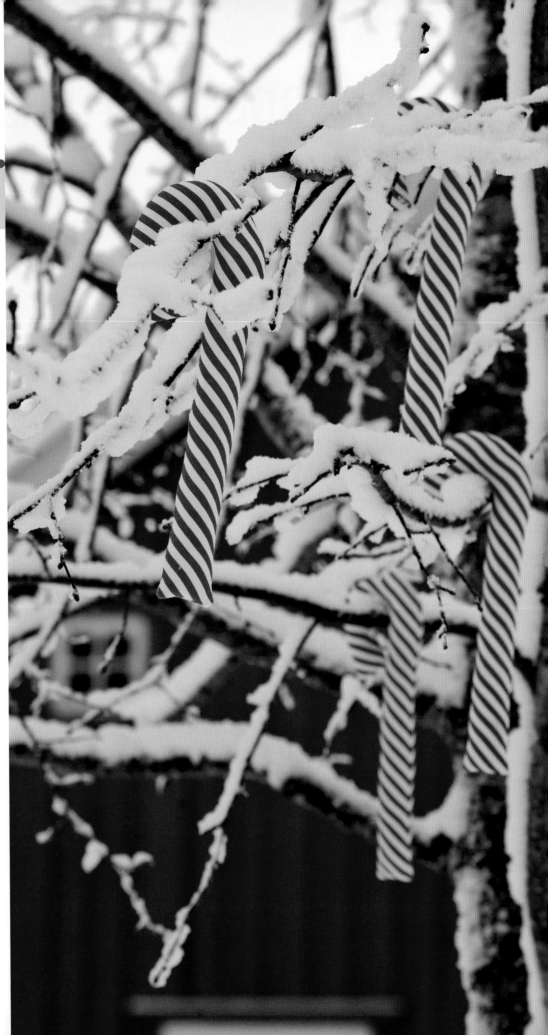

Ice-Scraper Mittens

The pattern for the mittens is on the folded insert at the back of the book.

The snowman is the same as the one used for the Christmas tree skirt but in a smaller size.

Trace the pattern. Cut two of the imitation fur pieces and two of the linen fabric pieces. Trace the parts of the motif on fusible web and transfer it to the fabrics you have chosen for the appliqué. Place the lower part of the motif 3 $1/2$ inches from the bottom edge of the mitten fabric. Place a few snowflakes around the mitten. Sew with blanket stitches around the motifs. Sew French knots for eyes and embroider the nose with satin stitches. Place the mitten pieces together, right side to right side, and sew around the edges. Remember to leave an opening for the ice scraper. Use the same procedure with the fur pieces, remembering the opening. Trim the seams. Fold a $3/4$-inch hem inwards at the bottom of the fur lining and sew the hem by hand. Place the fur lining inside the mitten and stitch up the pieces by hand along the edge of the mitten. Fold the edge of the fur up to the bottom edge of the mitten and attach the fur to the front piece with a few stitches by hand along the edge.

YOU NEED

Linen fabric
Various fabrics for
 appliqué
Imitation fur
Embroidery floss
Ice-scraper

Place the ice-scraper in the mitten. Sew a few stitches and tighten around the opening to keep the scraper in place if necessary.

These mittens with Christmas tree appliqués are a perfect gift for dad.

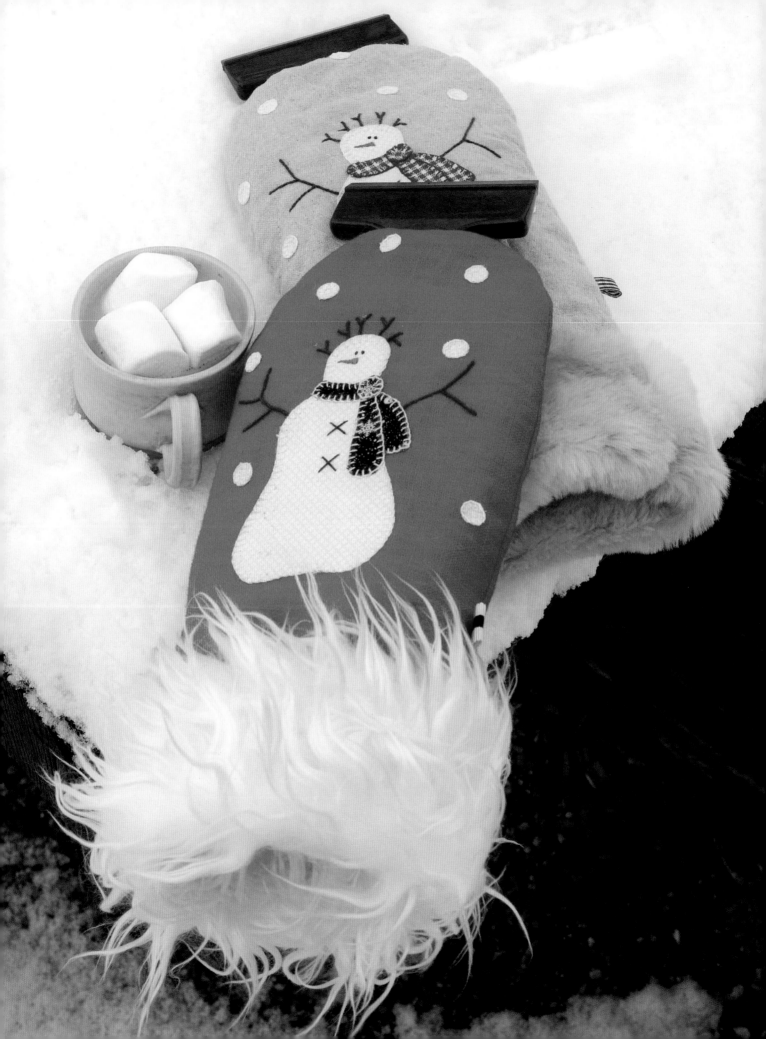

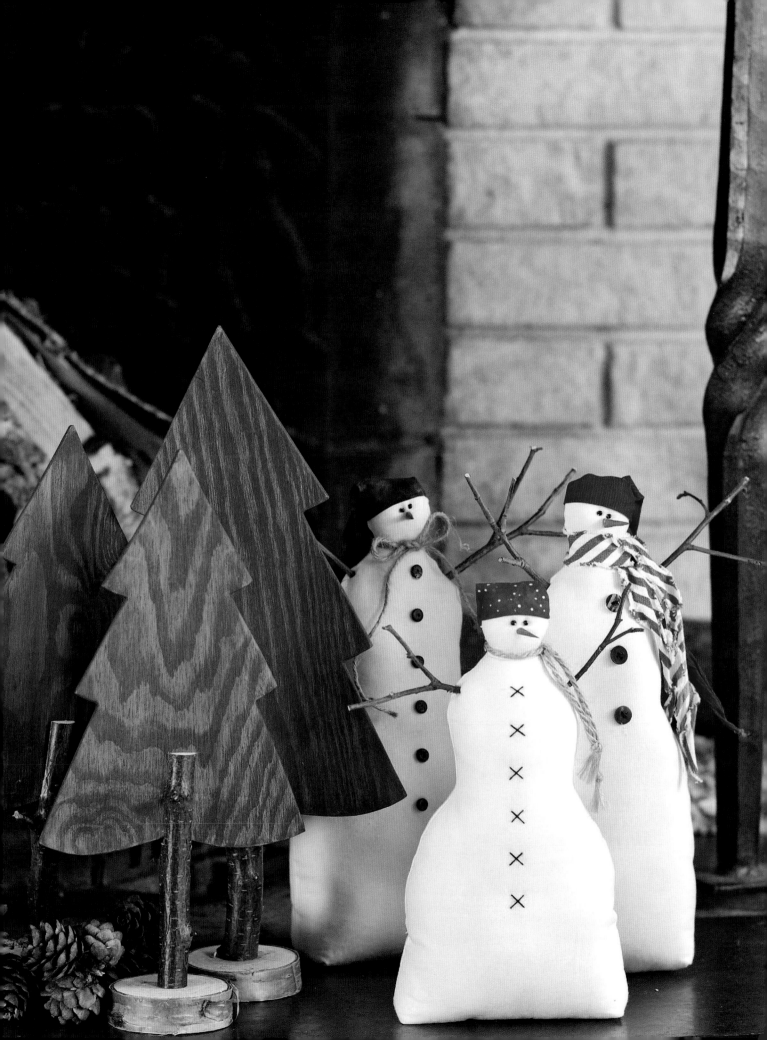

Snowmen and Christmas Trees

The pattern is on the folded insert at the back of the book.

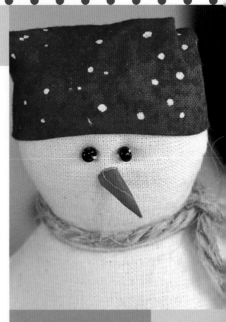

Snowmen

The snowmen are sewn in two different sizes. The large snowman is 12 inches tall, and the smaller one is 10 inches.

Fold the fabric in half, right side to right side. Trace the pattern and sew around the outside, remembering to leave a reverse opening at the bottom for turning the project and two openings in the sides for the twig arms. Cut the pieces out and cut notches in the seam allowance. Fold out the corners and sew a seam in each corner (see the instructions of the similar step for the bags on page 25). Turn the snowman inside out and iron. Stuff the snowman with fiberfill and some beads or rice at the bottom to help it stand steady. Stitch up the opening. Sew some crosses on the snowman's belly using embroidery floss, or attach a few small buttons.

HAT

Cut out the hat piece. Fold the bottom edge of the hat inwards and iron. Then fold it out again, fold the hat in half along the long side with the wrong side out, and sew along the side. Iron the folded edge inward, using flisofix to keep it in place. Turn the hat inside out and glue it to the snowman's head.

YOU NEED

Cotton fabric
Fabric for scarves and hats
Fiberfill
Beads or rice
Twigs
Buttons
Dowel or stick for nose
Black beads
Glue gun

TIP

Dip the hat and scarf in water and wring them out. Roll the pieces in a paper towel to remove as much water as possible. Roll the pieces between your hands to achieve a worn look. Shape the pieces and let them dry before attaching them to the snowman.

NOSE

Whittle a long, thin nose out of a dowel or stick. The nose should be $3/4$ inch long. Paint it with craft paint and use a glue gun to attach it.

EYES

Sew on little beads for eyes.

ARMS

We used twigs for arms on the snowman. Use a knitting needle to shape the holes for the twigs through the openings in the side seams. Apply some adhesive to the end of the twig and stick it $1^{1}/_{2}$ inches into the body.

SCARF

We ripped off a fabric strip 1 by 18 inches and tied it around the neck. You can also use yarn.

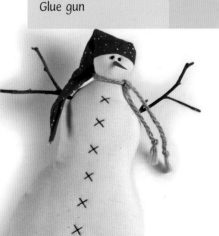

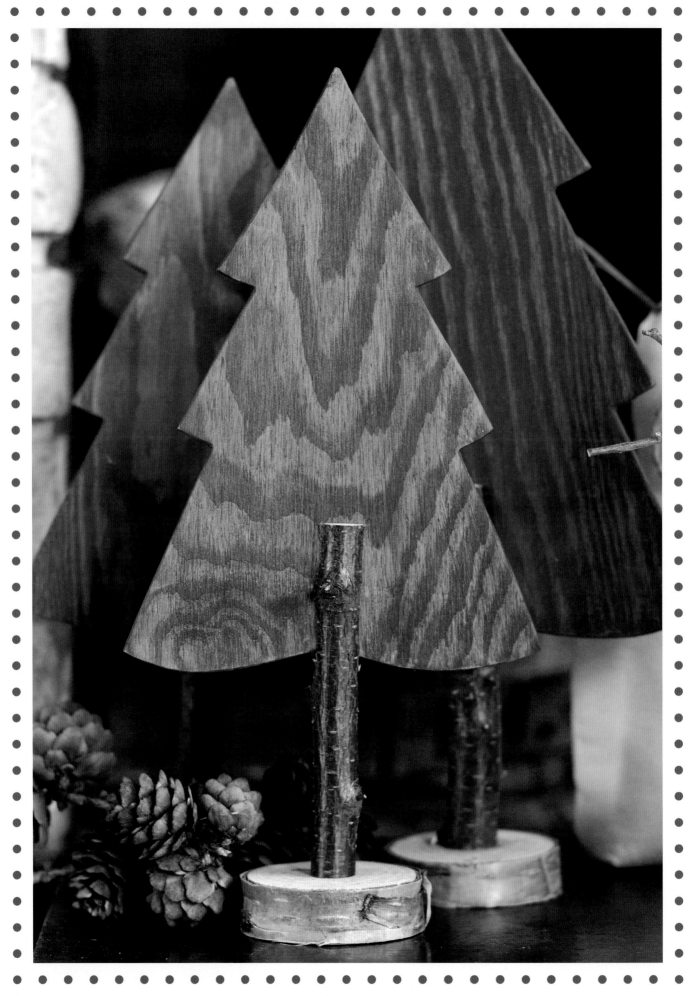

Plywood Christmas trees

The trees are made in two sizes.

Trace the pattern onto a piece of plywood. Cut and sand the surface and edges. Paint the tree. You could sand the edges some more after the paint is dry to get an old look. Cut a few small branches approximately $3/4$ inch in diameter in different lengths to use as tree trunks. Cut a notch $1/16$ inch deep at the end of a piece of branch approximately 2 inches long. Glue the tree to the notch. The stand is made of a piece of birch trunk approximately $2\,3/4$ inches in diameter. Cut slices about $3/4$ inch thick from the trunk. Drill a hole through the middle of the birch slice. Attach the tree to the stand by screwing a screw through the stand and up through the tree.

We sanded the edges of the tree on this page to give it an old look.

YOU NEED

Plywood
Tree branches
Paint
Screws
Wood glue

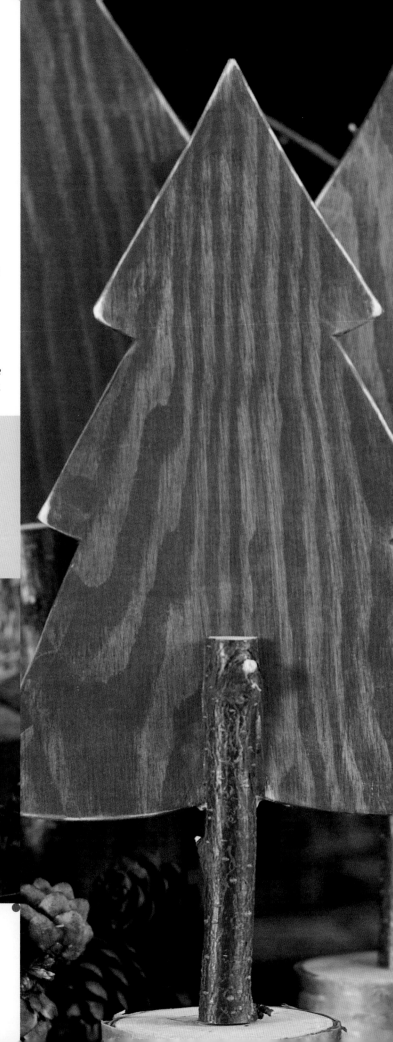

Christmas trees and pinecones belong together! We collected different decorative cones in cute little folding bags (see instructions on page 25) to display with our trees.

Hanging Lights

YOU NEED

Strong steel wire and
 thin wire

Twigs

Candleholders

Velvet ribbon

Various fabrics for the hearts

Fiberfill

String

Make a circle of a strong steel wire about 10 ¹/₂ inches across. Attach twigs to the circle of wire using thin wire. Cut four pieces of string of equal length (approximately 27 inches). You can use ribbon instead if you wish. Tie the strings to the circle, all an equal distance apart. Attach four candle holders in between the strings. Sew four hearts from different fabrics.

HEART

Fold the fabric in half and trace the pattern for heart. Remember to leave an opening for turning it inside out. Sew along the line and cut. Cut notches in the seam allowance. Turn inside out and iron. Stuff with fiberfill and stitch up the reverse opening. Sew on ribbons as hangers.

Opening

Attach hearts or other decorations to the circle.
If you embroider the numbers 1 to 4 on the hearts, this will make a great advent wreath.

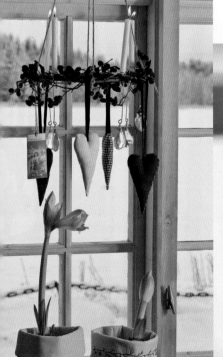

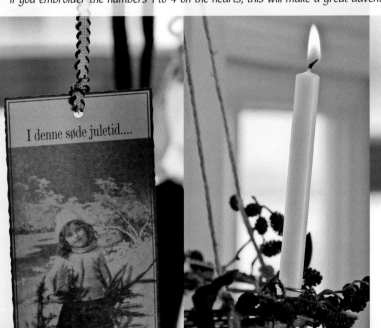

I denne søde juletid....

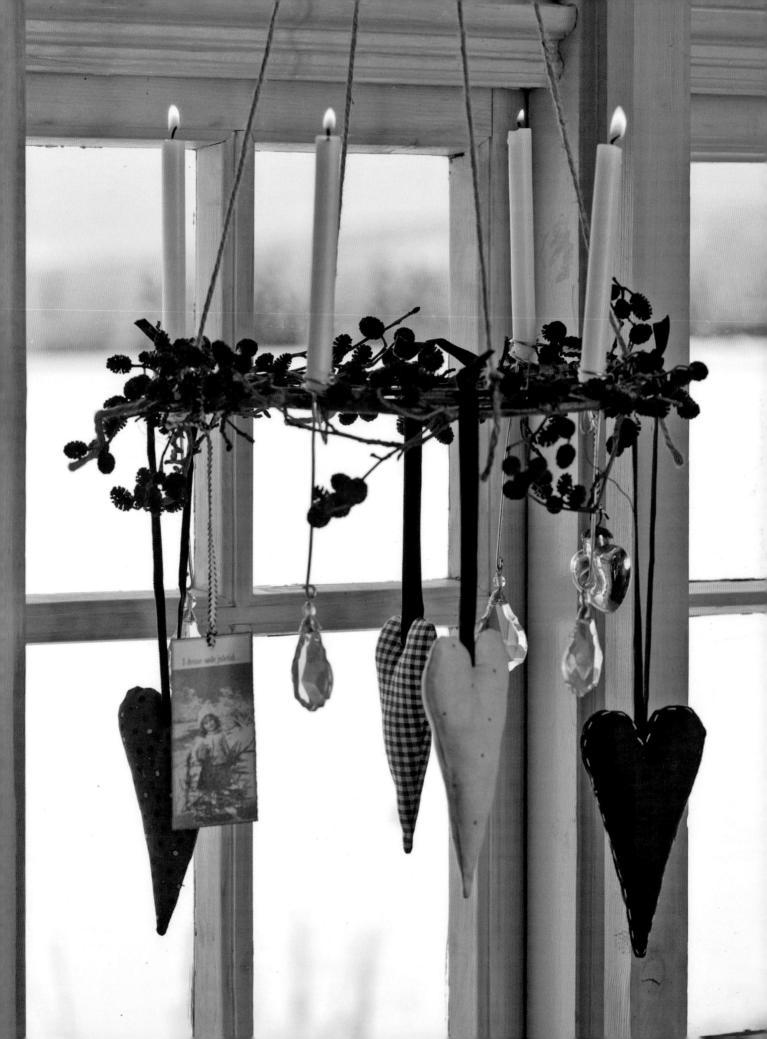

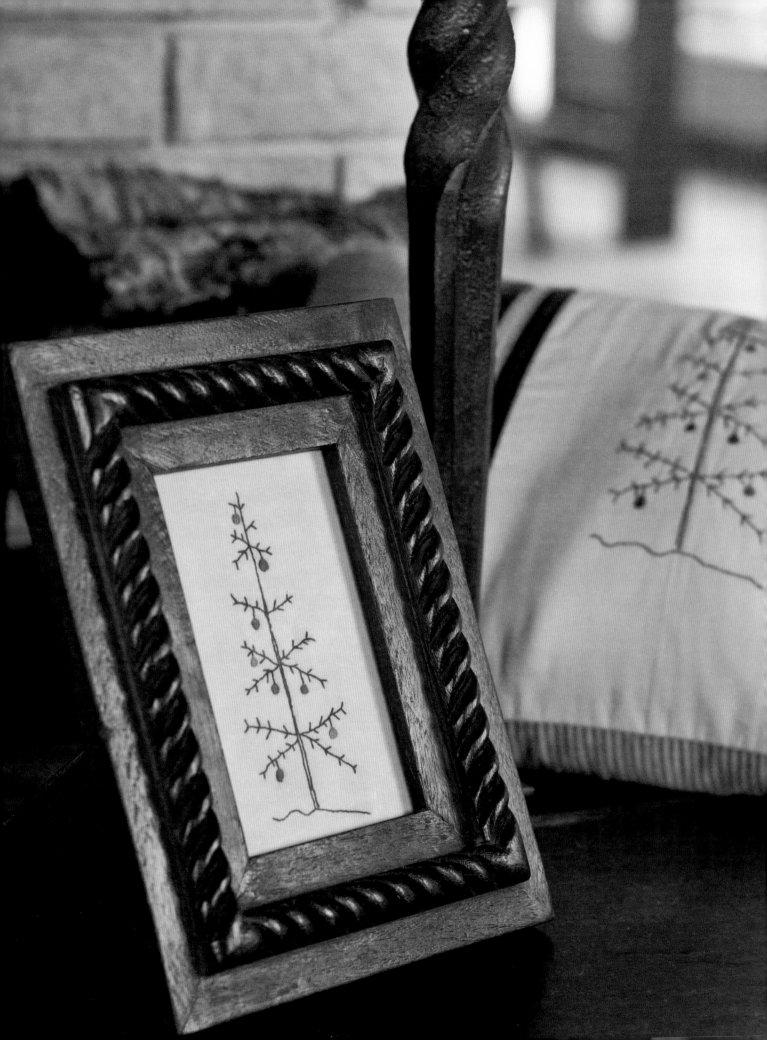

Framed Embroidered Motif

Use a photocopier to enlarge or reduce the pattern so it will fit the frame you have chosen. Cut a piece from a light-colored fabric ³/₄ inch larger on each side than the opening of the frame. Cut a piece of batting that is the same size as the opening. Transfer the pattern to the fabric.

Place the fabric in the middle of the batting and baste to keep the pieces in place. Embroider the motif. Iron the picture and place it in the frame. Attach the back piece of the frame.

YOU NEED

Light-colored fabric
Quilt batting
Embroidery thread
Frame

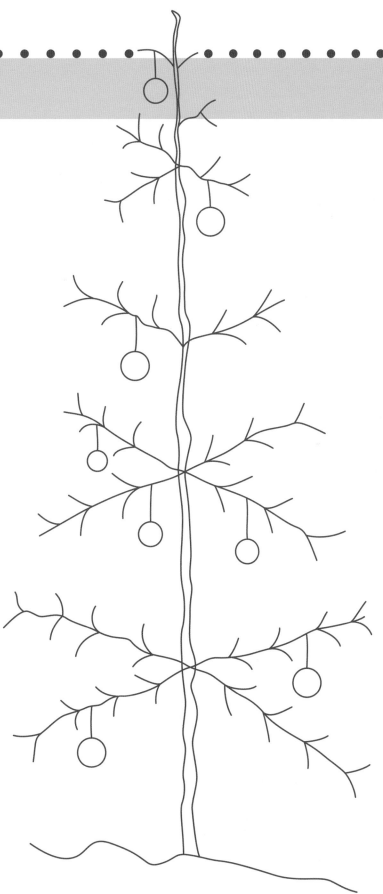

Brown Pillow with Embroidered Tree

The pattern is on page 55.

Cut two pieces of fabric 7 3/4 by 16 inches, one piece 9 3/4 by 16 inches, and one piece 19 1/2 by 16 inches. Cut a piece of light-colored fabric for quilting, 9 1/2 by 16 inches, and a piece of quilt batting 9 1/2 by 16 inches.

FRONT
Transfer the pattern to the light-colored fabric. Place the fabric piece on top of the batting and baste the pieces together so they stay in place. Embroider the pattern. The ornaments on the tree are embroidered with satin stitches. Place one of the 7 3/4 by 16 inches fabric pieces on the embroidered piece with right sides together and stitch up the pieces along the long side. Do the same on the opposite side; see figure A. Sew a velvet ribbon on top of each seam. Sew a slightly wider velvet ribbon next to it, 1/2 inch away.

BACK
Fold over and iron 2 inches on the long side of the smaller piece. Fold the running edge 1/4 inch inwards toward the fold and iron. Sew the hem with a seam near the edge; see figure B. Do the same on the other piece, but here the hem will be on the short side. Sew four buttonholes only the edge of the smaller back piece.

Place the front piece with the right side up. Place the smaller back piece on top of the front piece, right side to right side, and then add the larger piece. The back pieces should now overlap each other by 1 1/2 inches. Sew a seam around the whole cushion. Sew zigzag stitches around the edge outside the seam to prevent the fabric from unraveling. Turn inside out and iron. Stitch on four buttons.

YOU NEED

Light-colored fabric
Quilt batting
Fabric
Embroidery thread
Buttons
Velvet ribbon
Pillow, 5 3/4 by 23 1/4 inches

A

B

C

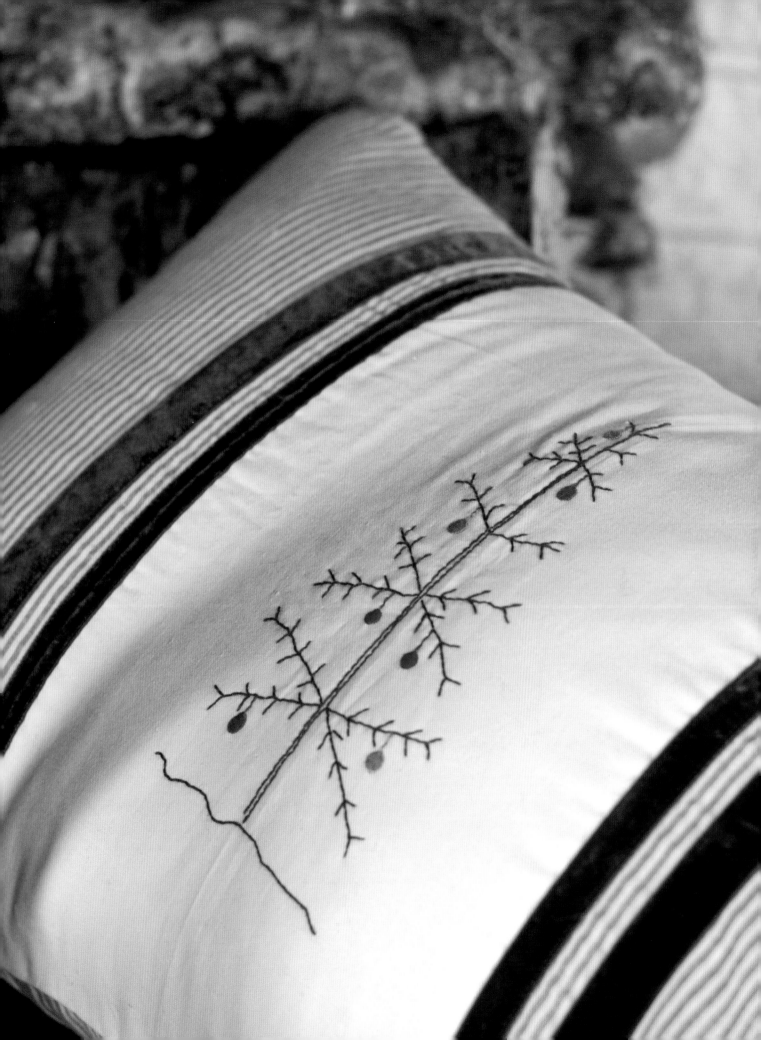

Personalized Cornucopias

The cornucopia pattern is on the folded insert at the back of the book.

Trace the pattern onto pieces of fabric folded in two. Place the edge of the pattern marked "fold line" against the folded edge of the fabric. Cut out the pattern from fabric, quilt batting, and lining fabric. Write out the names and trace them onto paper with a dark pen. Place a design below the name and trace it onto the same tracing paper. Transfer the pattern to the fabric; the top of the letters should be about $1\frac{1}{2}$ inch from the top edge. Place the quilt batting below the fabric (that you just transferred the pattern to) and baste so the batting will stay in place. Embroider the motif. Place the fabric piece and lining piece against each other, right side to right side. Sew the pieces together along the curved edge on top of the cornucopia. Cut clean.

Fold out the cornucopia and sew the side seams; see figure A. Remember to leave an opening to turn the project. Trim any extra seam allowance along the edge. Turn the cornucopia inside out and stitch up the opening. Push the lining into place with a knitting needle, leaving $\frac{1}{16}$ inch of lining above the edge. Iron the cornucopia and baste a decorative seam about $\frac{1}{8}$ inch from the edge. Thread the hanging string through the cornucopia. Make a knot outside the cornucopia to keep the string in place.

A

YOU NEED

Cotton fabric
Quilt batting
Lining fabric
Embroidery thread
String

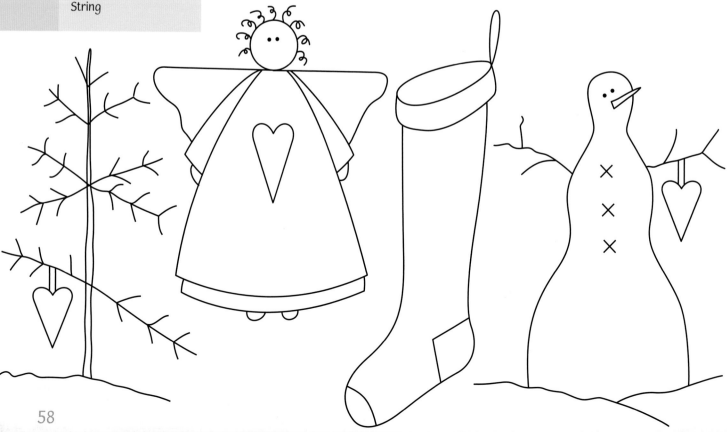

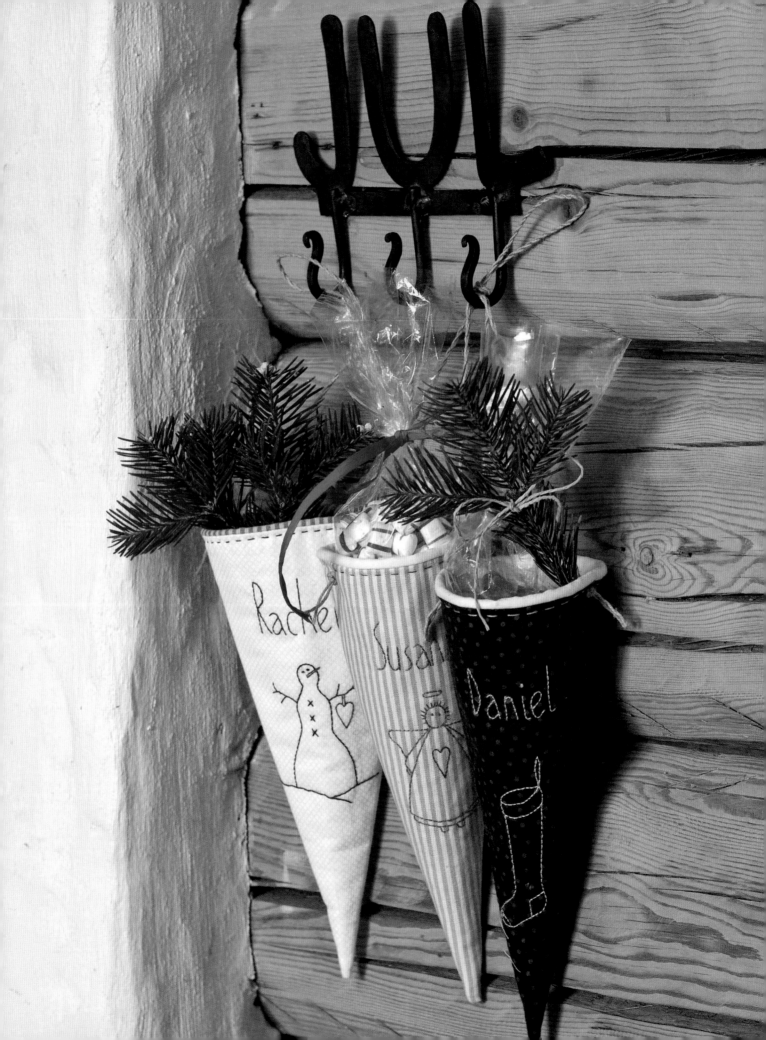

Cute Gift Ideas

Recipe book

Cut a piece of cardboard that will fit inside the pocket of the notebook. Cut a piece of decorative paper $3/4$ inch smaller than the cardboard on all sides. Glue the paper to the cardboard. Decorate the front with tags and stamped designs. Personalize the recipe book—for example, by writing the year and the name of the recipient. If it's a ring binder, you can tie ribbons and string to the rings.

YOU NEED

A notebook with a
 plastic pocket in front
Different types of paper
Ribbon

TIP

Write out one of your favorite recipes and put it inside the notebook to share with your friend. It's a great and very personal gift.

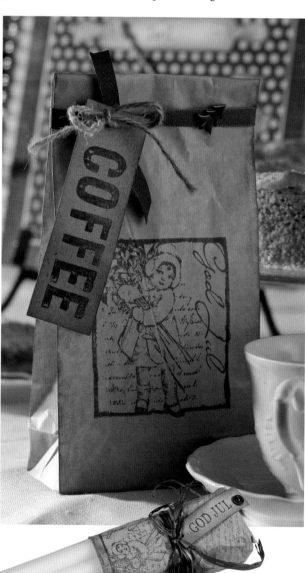

Coffee bag

This is a gift that is nice to give away and great to get. Fill a paper coffee bag (you can ask to buy one from your local coffee shop) with good coffee or tea. To make the gift even more personal, you can stamp the bag before filling it up. Decorate with ribbons and brads, and make a little card to write the contents of the bag on. Attach the card to the bag with a nice ribbon.

Bundle of candles

Wrap a bundle of candles in a paper you decorated with stamps. Tie together with rafia and attach a homemade tag.

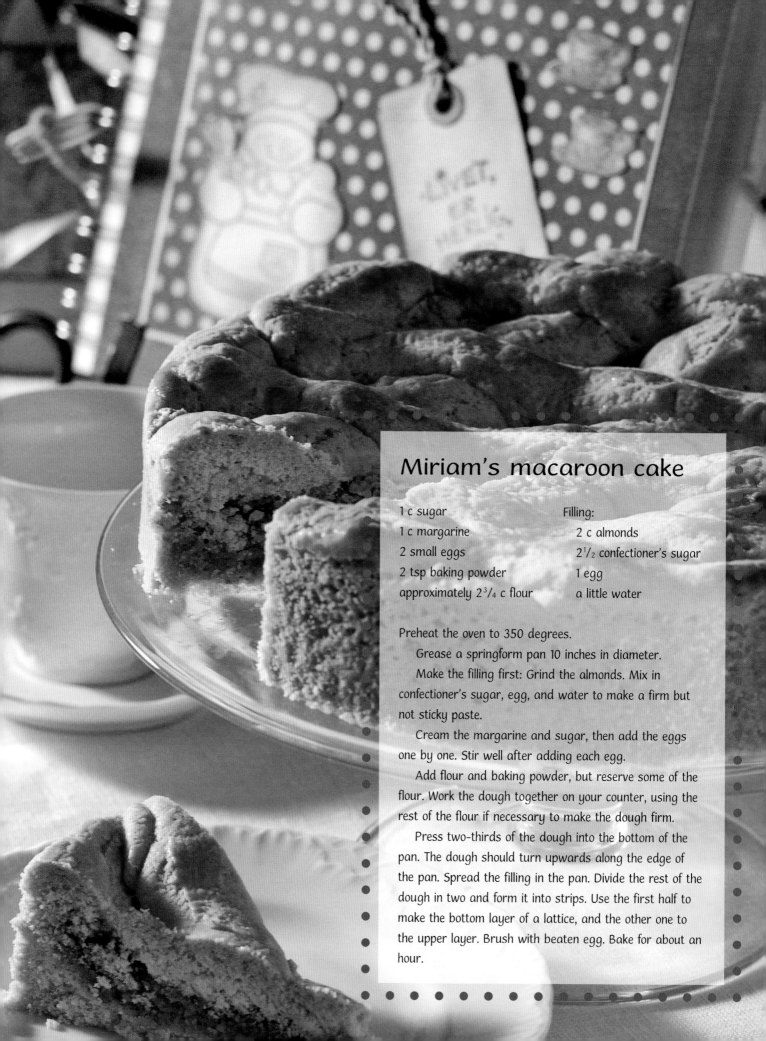

Miriam's macaroon cake

	Filling:
1 c sugar	
1 c margarine	2 c almonds
2 small eggs	$2^1/_2$ confectioner's sugar
2 tsp baking powder	1 egg
approximately $2^3/_4$ c flour	a little water

Preheat the oven to 350 degrees.

Grease a springform pan 10 inches in diameter.

Make the filling first: Grind the almonds. Mix in confectioner's sugar, egg, and water to make a firm but not sticky paste.

Cream the margarine and sugar, then add the eggs one by one. Stir well after adding each egg.

Add flour and baking powder, but reserve some of the flour. Work the dough together on your counter, using the rest of the flour if necessary to make the dough firm.

Press two-thirds of the dough into the bottom of the pan. The dough should turn upwards along the edge of the pan. Spread the filling in the pan. Divide the rest of the dough in two and form it into strips. Use the first half to make the bottom layer of a lattice, and the other one to the upper layer. Brush with beaten egg. Bake for about an hour.

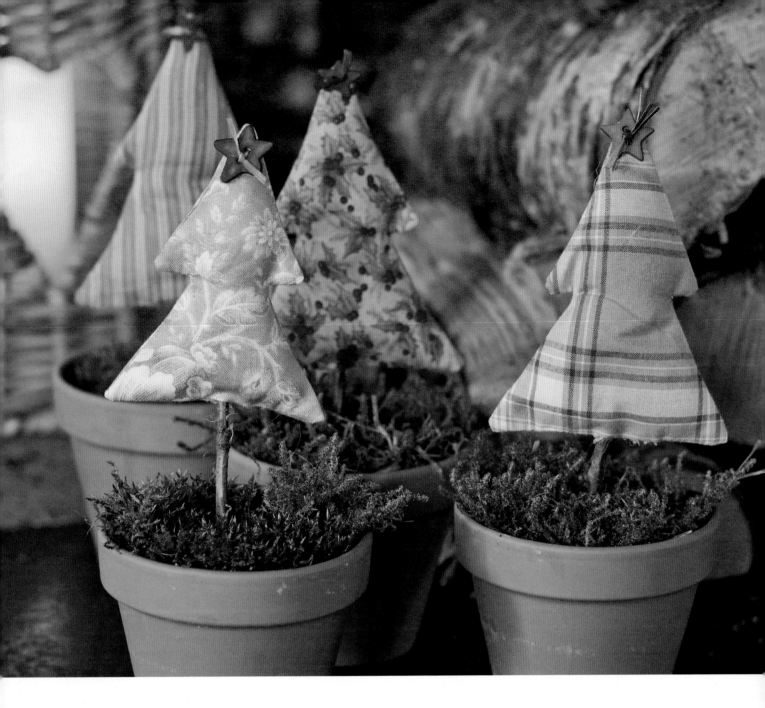

Mini Christmas Trees

The pattern is on the folded insert at the back of the book.

Fold the fabric in half and trace the pattern. Sew around the line. Cut out the tree. Cut notches in the seam allowance. Turn the tree inside out and iron. Stuff it with fiberfill. Use a twig as a trunk for the tree. Put the twig in the opening you used to turn the tree and stitch up the opening with basting stitches. Sew a star button to the top.

Assorted cotton fabric
Twigs
Fiberfill
Star-shaped buttons

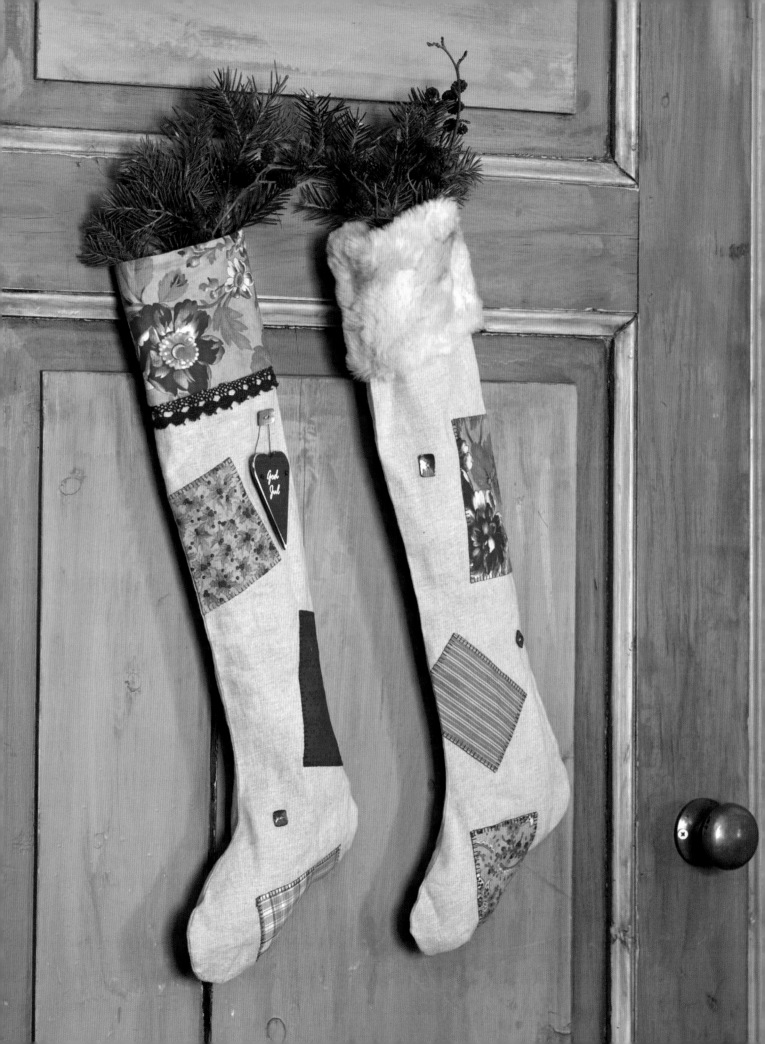

Christmas Stockings

The pattern is on the folded insert at the back of the book.

The two stockings are sewn in slightly different ways.

Stocking with lace

Trace the pattern, which consists of two parts: the stocking and the trim on top.

Fold the fabric in half and cut out the stocking part. Fold the trim fabric in half, place the edge of the pattern marked "fold line" against the folded edge of the fabric, and cut the piece out. Open up the trim fabric, fold it in half right side to right side, and sew the side seam. Iron the seam. Turn the trim inside out and iron.

Cut three patches in different fabrics and sizes. Iron fusible web to the backs of the patches. Iron the patches to the front of the stocking. Sew the patches to the stocking with blanket stitches. Cut off any excess fabric. Place the stocking pieces together, with the right sides inwards, and stitch up the stocking in front about 8 inches from the top edge. Sew a zigzag seam along the edge to keep the material from unraveling. Fold out the stocking with the right side facing up and add the lace with the running edge at the top of the stocking. Sew a seam $1/8$ inch right by the edge to keep the lace in place. Place the parts of the stocking together again, right side to right side, and stitch up the rest of the stocking. Sew zigzag stitches along the rest of the edge. Iron and turn inside out.

Attach the trim to the upper part of the stocking, with the running edge upwards and the seam on the back side. Stitch up the parts and sew zigzag stitches along the running edge. Attach a string for a hanger at the back, inside the stocking. Sew a few buttons as decoration in between the patches.

Stocking with fur

Trace the pattern, which contains two parts: the stocking and the fur trim. Fold the fabric in half and cut out the stocking part. Cut out the fur part. Sew patches to the stocking the same way as for the stocking with lace.

Place the parts of the stocking together, right side to right side, and sew around the edge. Sew zigzag stitches along the running edge. Iron and turn inside out. Fold the upper part of the stocking inwards, to the dashed line marked on the pattern. Iron. Sew the seam at the back of the fur piece. Fold in and sew a $3/4$-inch hem at the bottom of the fur by hand. Place the fur piece inside the stocking with the seam at the back and the right side of the fur against the inside of the stocking. Stitch up the parts. Reverse the fur over to the right side. Sew a string for a hanger to the middle of the back of the stocking. Stitch on a few buttons between the patches.

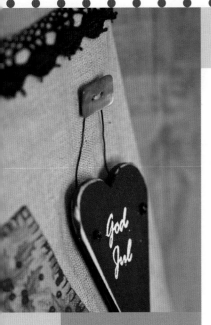

YOU NEED

Various cotton fabrics
Linen
Imitation fur
Lace
Buttons
String
Batting

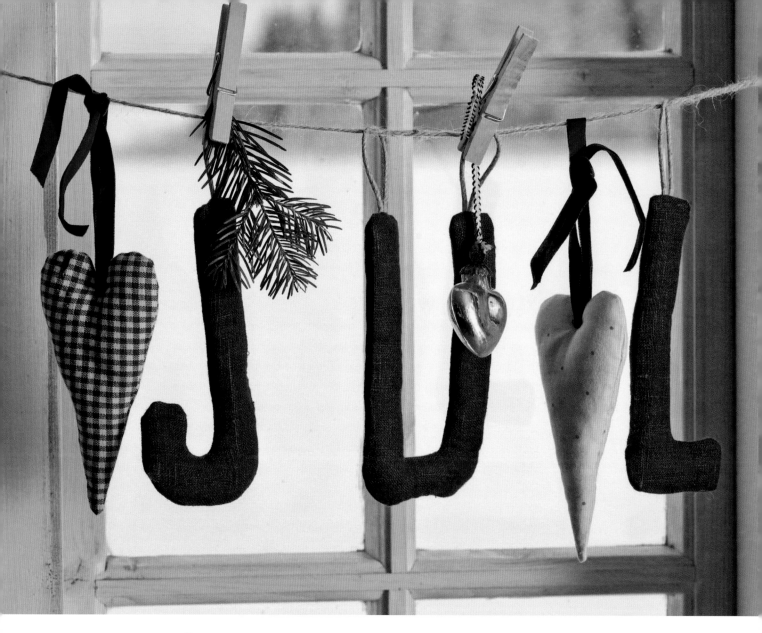

Window Hanging

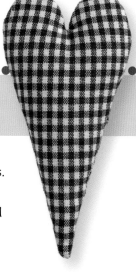

The pattern is at the back of the book.

This festive window hanging spells the Norwegian word for Christmas.
Fold the fabric for the letters in half and trace the pattern. Mark the openings and sew around. Cut out the letters. Turn inside out and iron. Stuff with fiberfill and stitch up the openings. Attach a string or ribbon for a hanger.

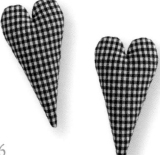

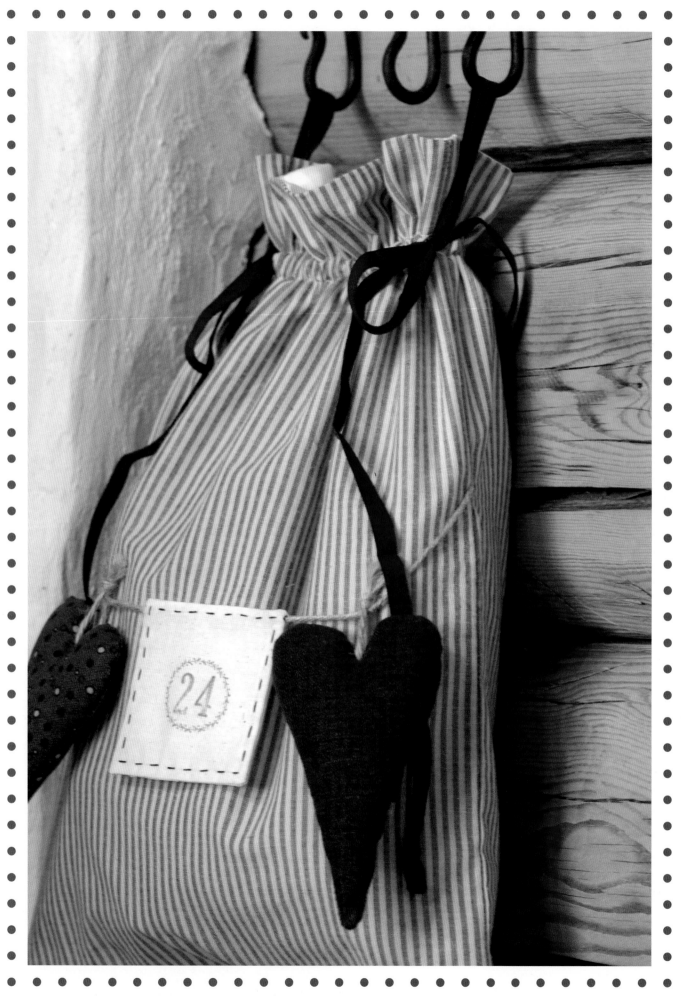

It's Christmas Eve . . . and the children can't wait to see what's in the bag!

Stocking Ornaments

Cut out the pattern twice from linen or cotton fabric. You can transfer the pattern to the right side of the fabric, if you don't want to embroider freehand. Embroider the motif on the stocking. Place the parts right side to right side with a string as a hanger between parts where marked. Sew the parts together, remembering to leave an opening. Turn the stocking inside out, stuff it with fiberfill, and stitch up the opening.

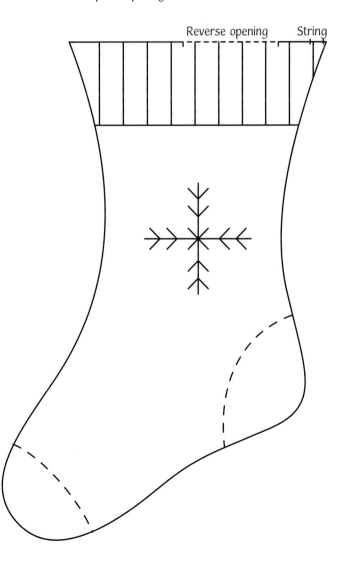

Reverse opening String

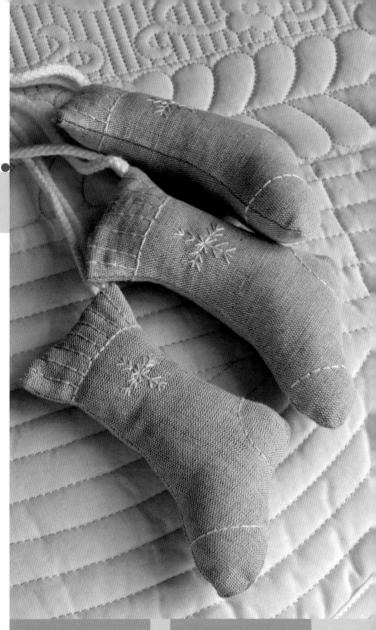

YOU NEED

Linen or cotton fabric
Ribbon or string
Embroidery thread
Fiberfill

TIP

Fill the sock with lavender to make a holiday sachet.

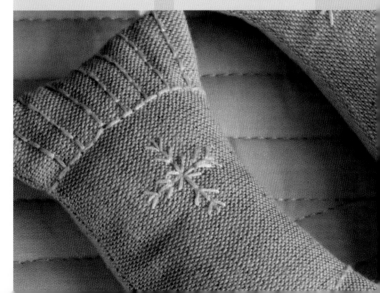

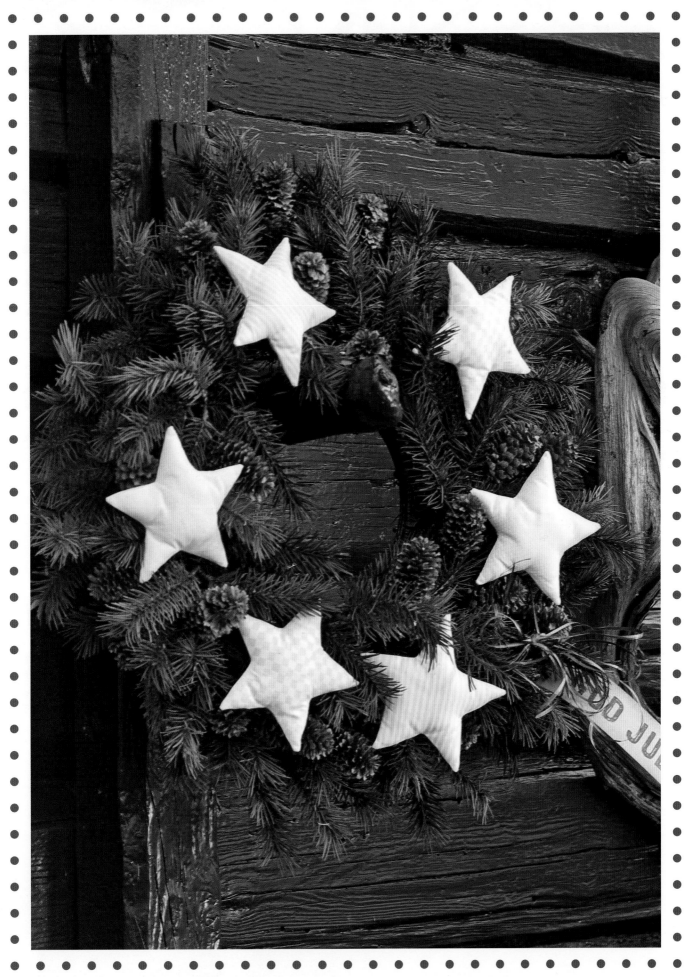

This wreath is made the same way as the wreath on page 105, but here we have decorated it with stars (see page 10).
Tip: Stamp Merry Christmas on a tag and attach it to the wreath with rafia.

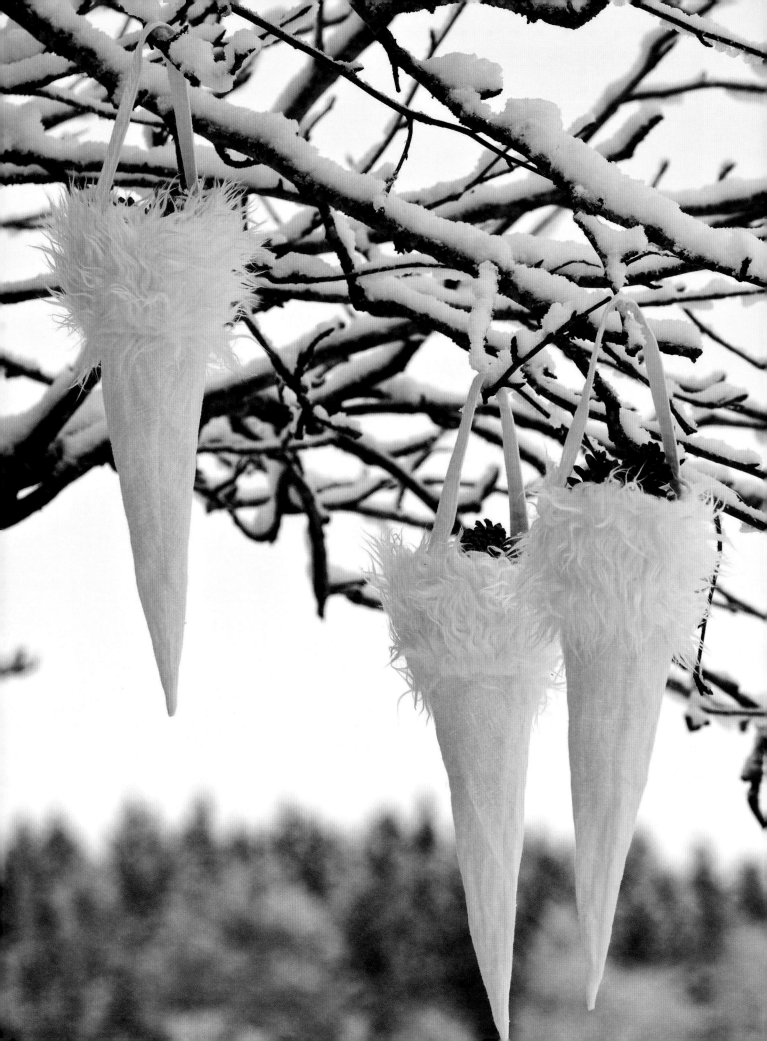

Winter White Cornucopias

The pattern is on the folded insert at the back of the book.

The winter white cornucopias are made the same way as the large cornucopia on page 12. The finished length is 25 inches.

Handle

Cut a strip of fabric 3 $\frac{1}{2}$ by 16 inches for the handle. Cut a strip of fusible web 1 $\frac{1}{4}$ by 16 inches. Iron the fusible web to the middle of the fabric strip. Rip off the paper and fold the edges in towards the middle. Iron so the finished handle is 1 $\frac{1}{4}$ inch wide. Sew a velvet ribbon across the splice with a seam on each side.

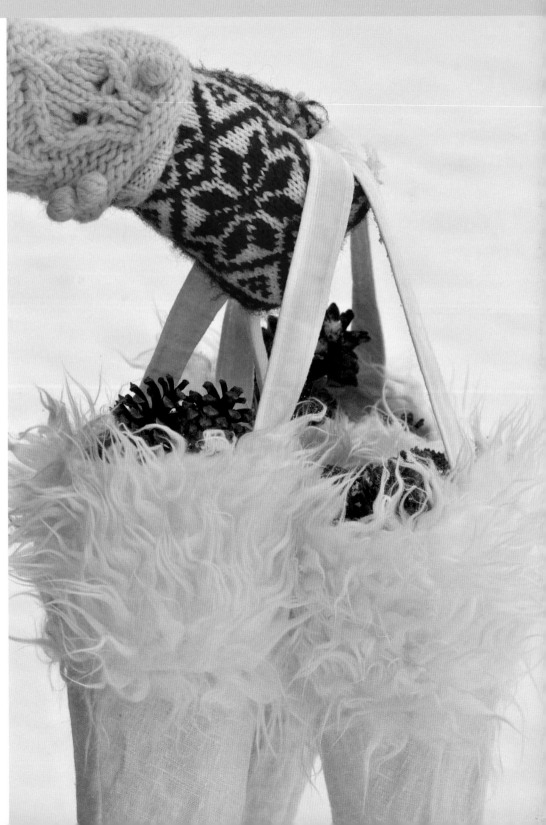

Christmas Mouse

The pattern is on the folded insert at the back of the book.

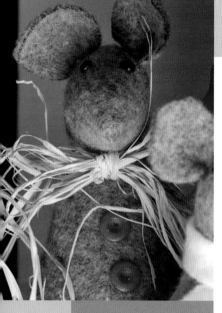

YOU NEED

Felt
Yarn
Buttons
Ribbon/rafia
Fiberfill

Choose a size and cut our two body pieces and two ears. Sew around the parts for the body, but leave the bottom open. Turn the body inside out, iron, and then stuff with batting. Baste around the bottom edge of the mouse with two strands of sewing thread and gather the bottom. Tie off the thread and fasten down the ends. Felt won't fray, so you don't need to hem any of the edges. Baste the ears to the head; see figure A. Stitch on buttons for eyes or glue on beads. Tie rafia or a ribbon around the neck. You can make a scarf from a piece of felt, approximately ³/₄ by 11³/₄ inches. Cut fringes on both ends.

A

Hat: Cut a triangle of red linen. Sew the side seam, then fold the bottom edge of the hat inwards and iron. Reverse and sew the hat to the head.

Make the tail by twisting two strands of wool yarn together and then folding them in half so that they twist back on themsevles. Stitch the tail to the mouse and decorate it with a bow if you wish.

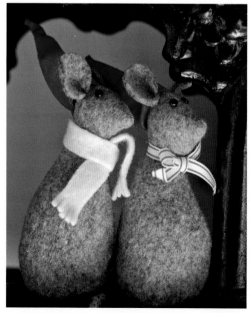

We have to watch out for the mousetrap so we can celebrate Christmas again next year . . .

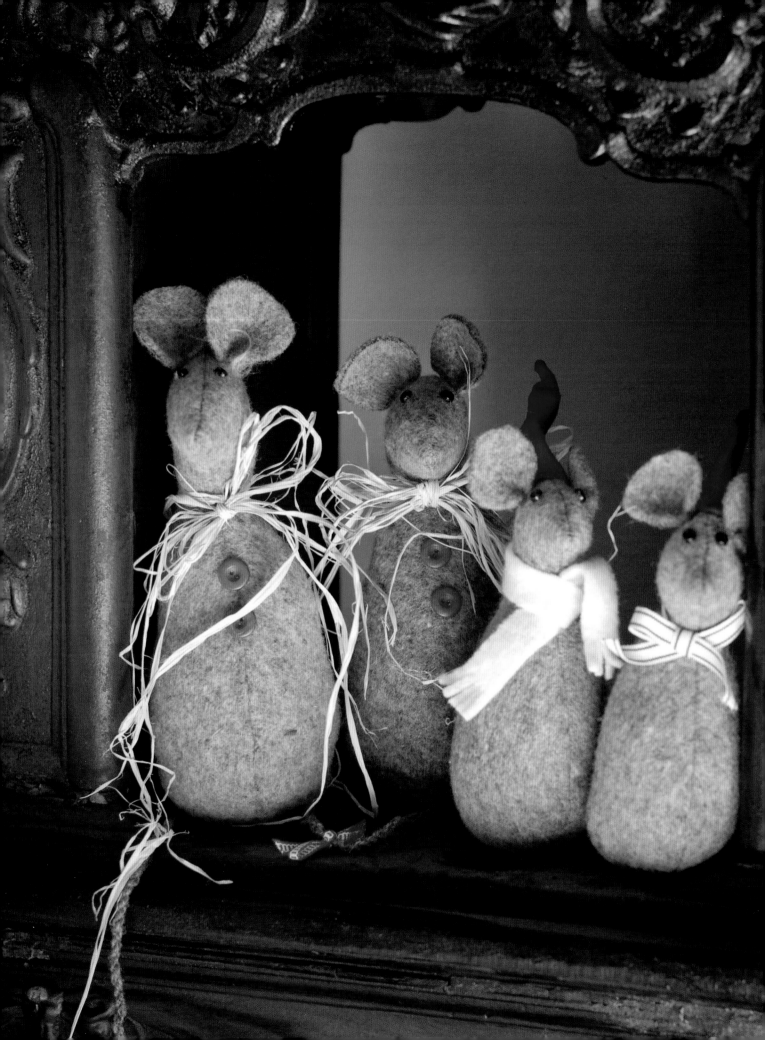

Candy Gift Bag

Cut a piece of fabric 20 $\frac{1}{2}$ by 7 inches for the bag, and another piece of fabric in a different color 6 by 13 $\frac{1}{2}$ inches for the trim. Use a thick or strong fabric for the bag since it is not padded. Place the parts for the bag right side to right side and sew the side seams. Sew a zigzag seam along the edge so the seams won't unravel. Fold the corners the same way as on the gingerbread cookie cutter bag on page 80, but sew the seam right across 1 inch in from the tip. Trim any excess fabric and sew zigzag stitches along the cut edge. Fold the piece of fabric for the trim in half and stitch up the border with a seam ending $\frac{3}{4}$ inch before the edge; see figure A. Iron the seam allowance on each side.

Fold the trim in half with the right side and opening out; see figure B. Place the trim inside the bag. The opening for the drawstring casing should be right above the side seam of the bag. Sew the pieces together. Sew a zigzag seam along the cut edge so the fabrics won't unravel. Iron the seams and turn the bag inside out. Sew a seam along the bottom of the trim, $\frac{1}{2}$ inch from the bottom, to form a casing for the drawstring. Thread a string through the casing so you will be able to close the bag.

YOU NEED

Thick cotton fabric
Regular-weight cotton
 fabric
String

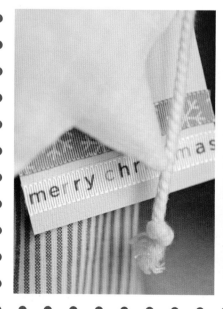

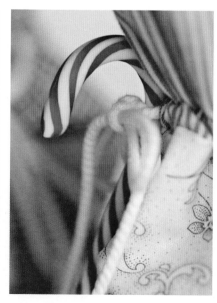

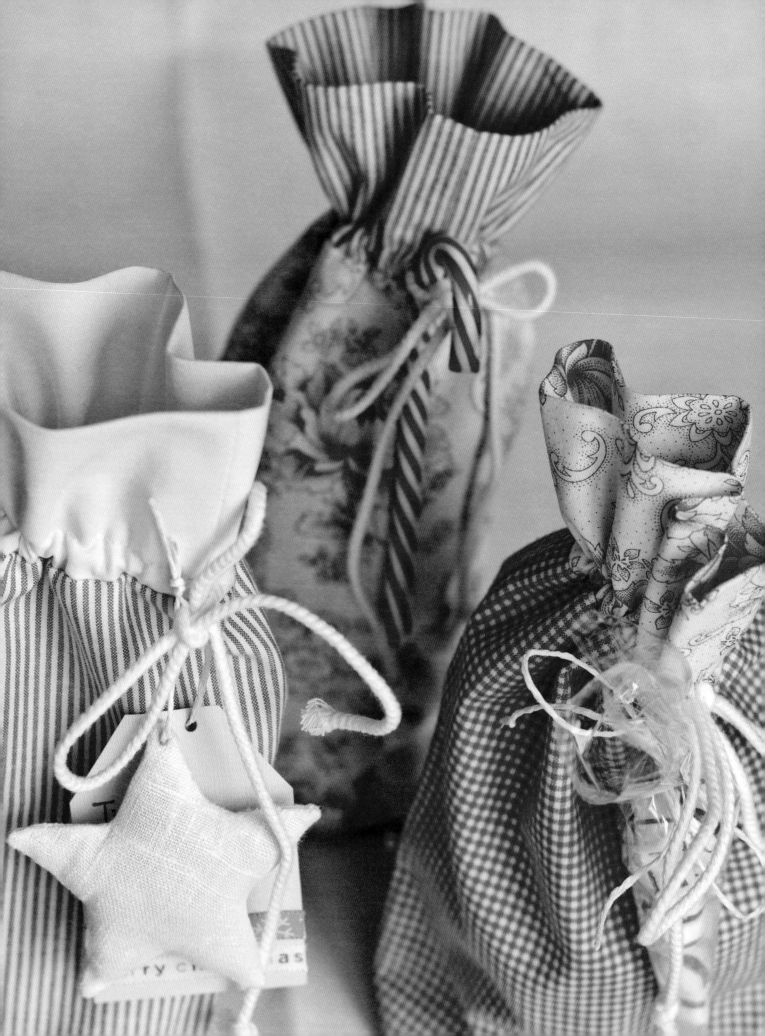

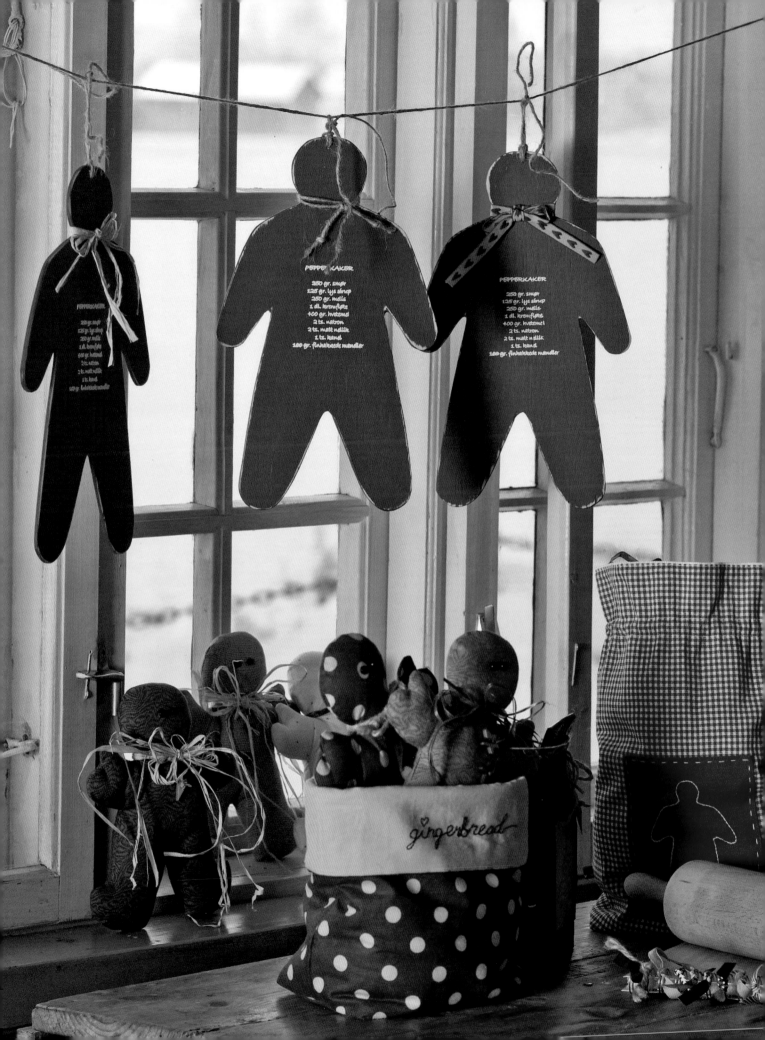

Wooden Gingerbread Men

The pattern is on the folded insert at the back of the book.

Trace the pattern for the gingerbread man onto plywood. Cut it out and drill a hole at the top. Sand the surface and edges with sandpaper. Paint the gingerbread with craft paint. When the paint is dry, sand the edges again to get a worn look. Emboss or stamp on the desired pattern. Attach a string for a hanger, and tie a string or ribbon around the neck.

YOU NEED

Plywood
Craft paint
Stamp
String
Sandpaper

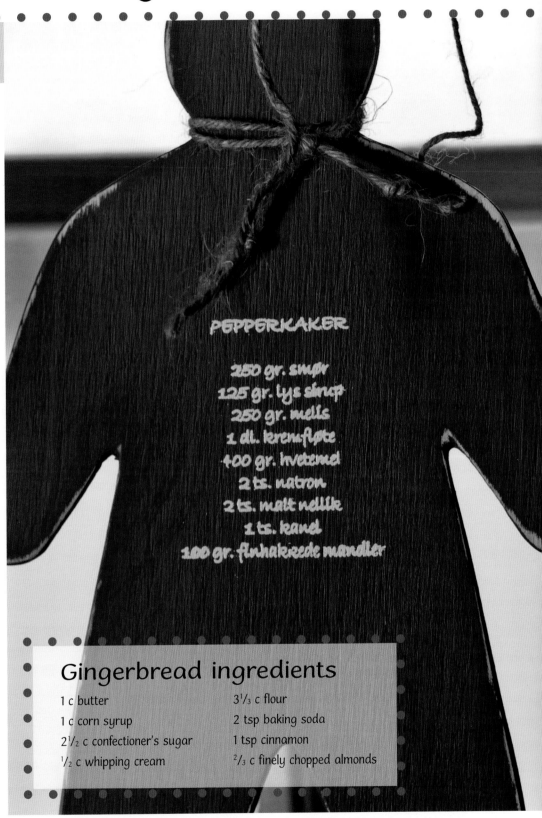

PEPPERKAKER

250 gr. smør
125 gr. lys sirup
250 gr. melis
1 dl. kremfløte
400 gr. hvetemel
2 ts. natron
2 ts. malt nellik
1 ts. kanel
100 gr. finhakkede mandler

Gingerbread ingredients

1 c butter
1 c corn syrup
2½ c confectioner's sugar
½ c whipping cream

3⅓ c flour
2 tsp baking soda
1 tsp cinnamon
⅔ c finely chopped almonds

Soft Gingerbread Men

The pattern is on the folded insert at the back of the book.

Fold the fabric in half with the right side inwards and trace the pattern. Mark the opening. Sew around the figure. Cut the figure out and cut notches in the seam allowance around the figure where the seams curve in. Turn the figure inside out and iron. Stuff with fiberfill and close up the opening. Sew two buttons to the figure for eyes and buttons to the rest of the body as desired. Another option is to sew crosses on the body with embroidery floss. Tie a piece of string, ribbon, or rafia around the neck in a bow.

The folded bag shown with the gingerbread men is the largest bag from page 25.

YOU NEED

Cotton or linen fabric
Fiberfill
Ribbon or string
Buttons

Seedcake

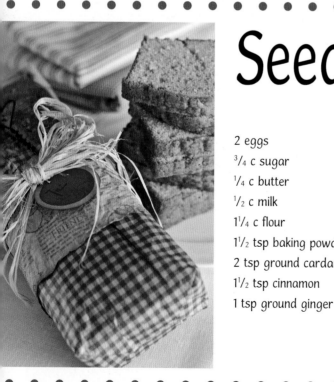

2 eggs
³/₄ c sugar
¹/₄ c butter
¹/₂ c milk
1¹/₄ c flour
1¹/₂ tsp baking powder
2 tsp ground cardamom
1¹/₂ tsp cinnamon
1 tsp ground ginger

Preheat oven to 350 degrees. Beat egg and sugar. Melt butter, add milk, and bring it to a boil. Quickly pour the hot mixture into the egg and sugar mixture. Add the flour and the other ingredients, and stir it all together. Pour the dough in a greased bread pan. Bake in the middle of the oven for about 35 minutes.

Tip:
Wrap the cake in cellophane, then nice wrapping paper with a homemade ribbon and a tag. Add a homemade cake decoration and tie a bow of rafia around the whole thing. It will be the nicest Christmas present!

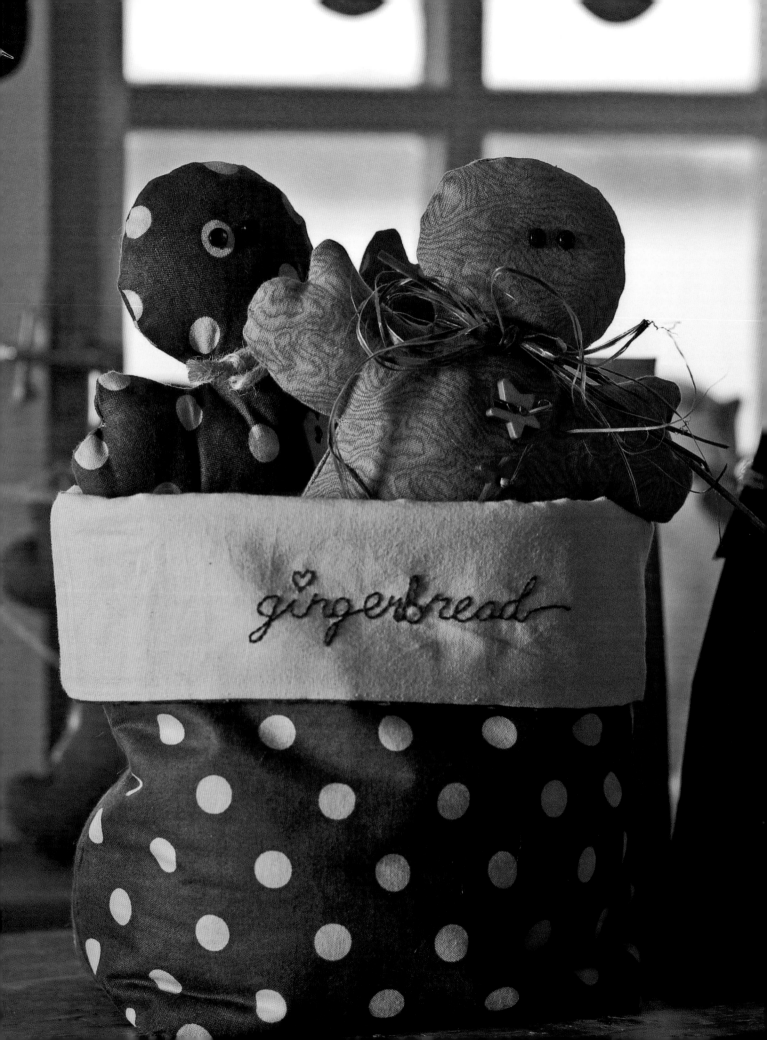

Cookie Cutter Bag

Cut a piece of fabric 29 by 10 inches, and a piece of lining fabric of the same size. Cut a piece of fabric to embroider on, 5 by 6 1/4 inches. Trace the pattern of the gingerbread man or woman and transfer it to the patch. Sew around the motif with stem stitches. Fold the end inwards 1/2 inch all the way around, and sew long basting stitches as a decorative seam around the hem, about 1/16 inch from the edge. Place the finished embroidered patch in the middle of the front side of the bag, about 6 1/2 inches from the top edge. Sew the patch to the fabric, with the seam right on the edge of the patch.

Fold the fabric in half with the right side facing in and sew the side seams. Be sure to leave an opening 1/2 inch wide, 2 inches from the top on one of the sides for the drawstring casing. Iron the seams. Sew the lining the same way, remembering to leave an opening in one of the side seams for turning the bag right side out. Iron the seams. Open the bag up and sew a seam right across each corner, about 1/16 inch in from the tip. Cut off the corners outside the seams; see figure A. Do this in all four corners (two on the bag and two on the lining). Turn the lining inside out and place it inside the bag with the right sides together. Sew the pieces together around the top of the bag. Turn the bag inside out. Close up the opening you used to turn the bag and iron. Place the lining inside the bag, but leave 1/16 inch of the lining on top of the bag. Iron. Sew two seams to make the casing, making sure the opening you left will be between these seams. Thread a string through the casing.

YOU NEED

Linen
Cotton fabric
Lining fabric
Embroidery floss
String

TIP

Make your own patterns by tracing around the gingerbread cookie cutters.

A

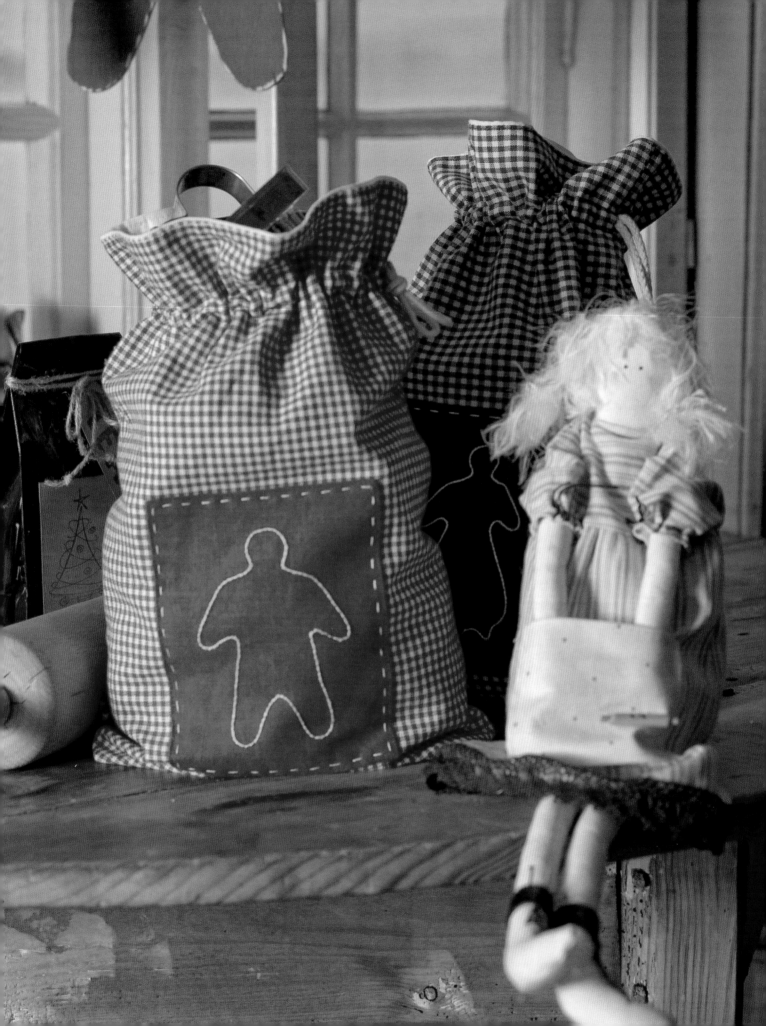

Mini Cornucopias

YOU NEED

Cotton fabric
Lining fabric
Fusible batting
String
Lace

The pattern is on the folded insert at the back of the book.

Trace the pattern. The fabric should be folded in half. Place the edge of the pattern marked "fold line" against the folded edge of the fabric. Cut out the pattern once from the outer fabric, once from the fusible batting, and once from the lining fabric. Iron the batting onto the outer piece. If you want lace on the cornucopia, it should be attached now.

Place the lace edge to edge with the curved line on top of the cornucopia, on the right side, and attach with basting stitches. Place the lining fabric on top with the right side against the right side of the front piece. Stitch up the layers along the curved edge. Stitch up the cornucopia the same way as the personalized cornucopias on page 58. Thread a string through the sides to hang the cornucopia.

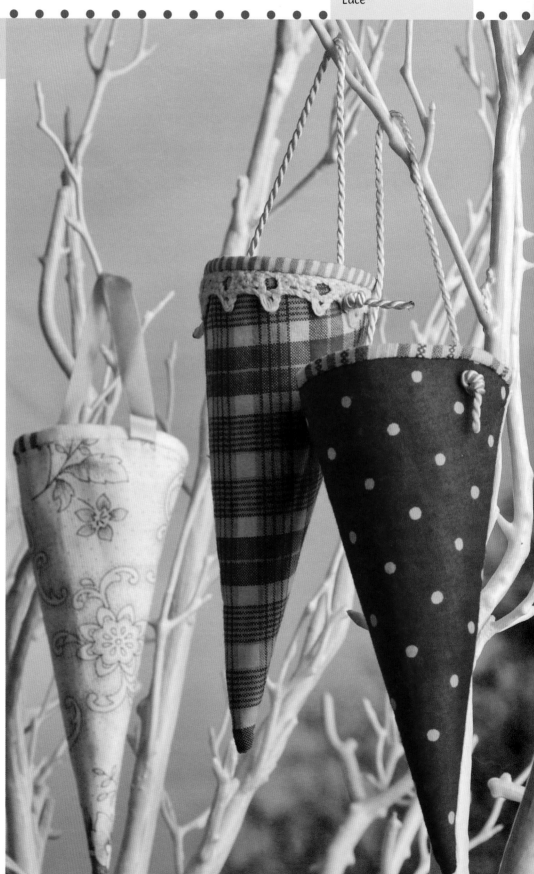

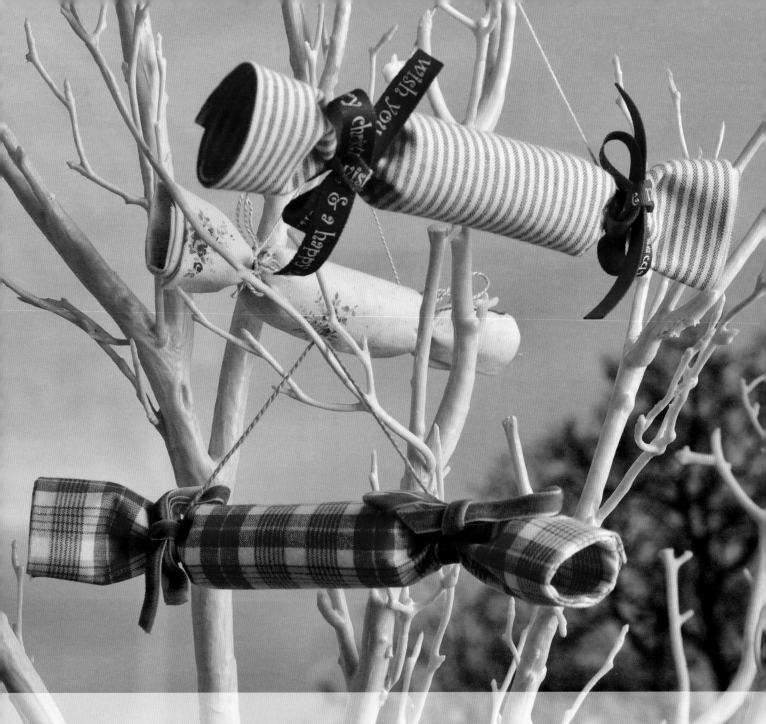

Christmas Crackers

Cut a piece of corrugated cardboard 2 1/2 by 7 inches and a piece batting 2 1/2 by 4 inches. Roll the cardboard into a tube and roll a layer of batting around it. Attach with tape. Cut a piece of fabric 7 1/2 by 9 1/2 inches. Iron a hem of 1 inch along the short sides inwards using fusible web. Make a hem of 1/2 inch in the same way on one of the long sides. Roll the fabric around the paper, starting with the long side where the cut edge is showing. Gather the fabric at the ends of the cardboard with thread and make a hanger from thread or ribbon. Decorate with bows.

YOU NEED

Various cotton fabrics
String
Cardboard
Thin batting
Fusible web

Plywood Angels

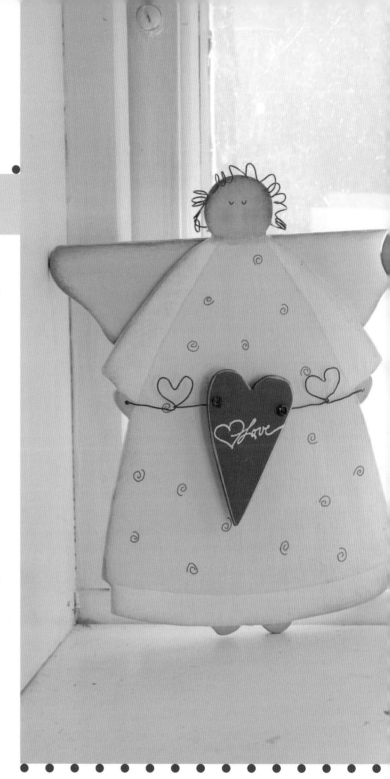

The pattern is on the folded insert at the back of the book.

Trace the pattern for the angel, wing, and heart on the plywood. Cut out the pieces. Drill small holes (2 mm) where marked on the hands and heart to attach the wire. Also drill small holes on each side of the head, approximately 1 mm in diameter. These holes are to attach the hair. Sand all surfaces and edges on all pieces.

YOU NEED

Plywood
Steel wire
Craft paint
Brown stamp pad

Prime the plywood with the color for the dress. We used white and turquoise. Lightly sketch the lines between the face, apron, hands, and feet with a pencil. Paint the face, hands, and feet with craft paint. We painted the aprons beige, white, and red. The wings are painted a skin color. The hearts are painted in red, brown, and beige. Stamp or emboss the text on the heart. Decorate the aprons. The angel with the beige apron has a spiral pattern drawn with a waterproof felt-tip pen. The angel with the white apron has brown dots made with the head of a pin. The angel with the red apron has small stars made with a stamp.

Assembly

Attach the heart to the angel with a thin wire. Start by twisting the wire around a thin knitting needle. Thread the wire through the right hole on the heart and shape a heart before threading the wire through the right hand. Twist the wire on the back to attach it. Do the same procedure on the left side.

For hair, we wound a wire into a spring and attached it to the holes on both sides of the head. Use some adhesive in the holes to attach the wire. Use a sponge to apply ink from a brown ink pad around the edges of the angel. Attach the wings with adhesive.

Draw two small eyes with a waterproof felt-tip pen and use a brush and a pink stamp pad to make rosy cheeks.

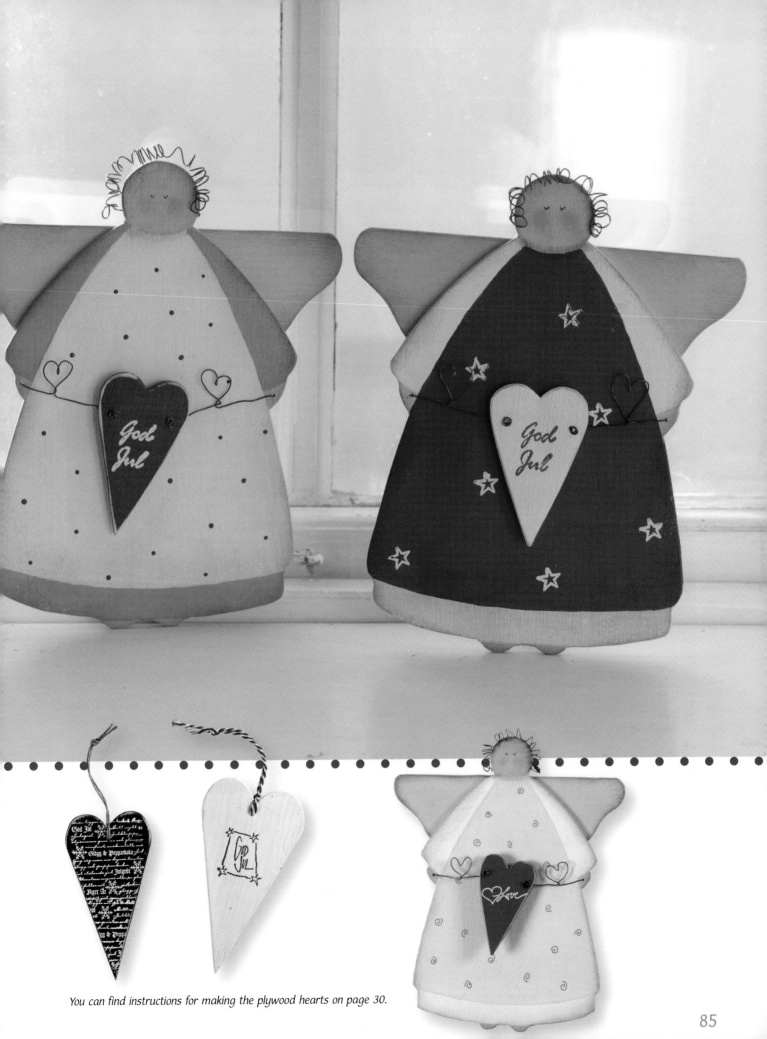

You can find instructions for making the plywood hearts on page 30.

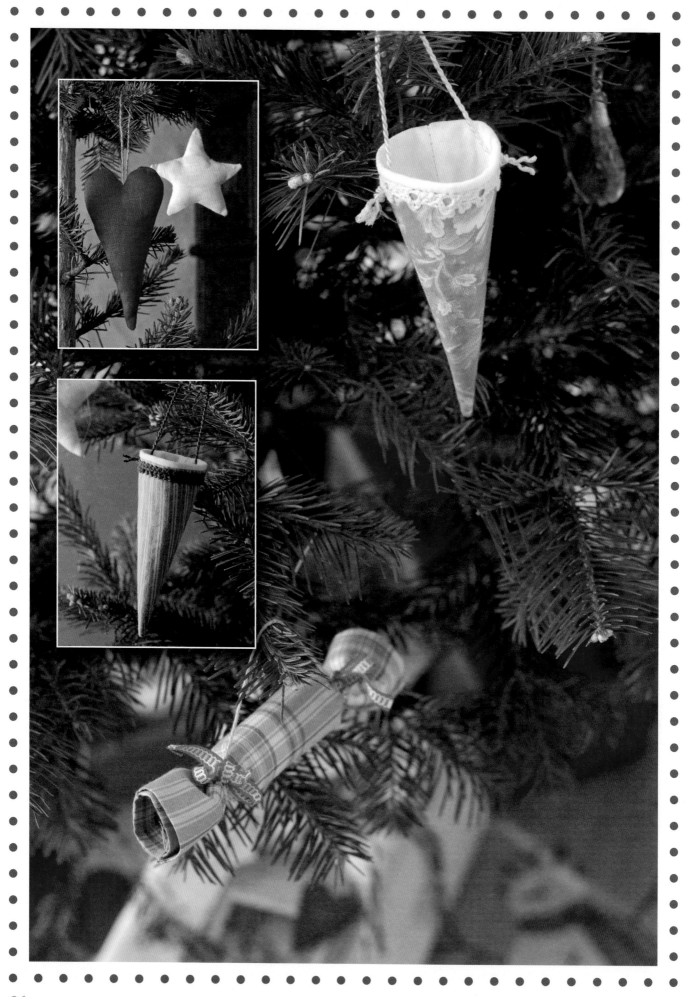

Christmas Tree Ornaments

Homemade Christmas ornaments are a pleasant gift to receive. Make a nice gift box and fill it with a few hearts, stars, mini cornucopias, and Christmas crackers.

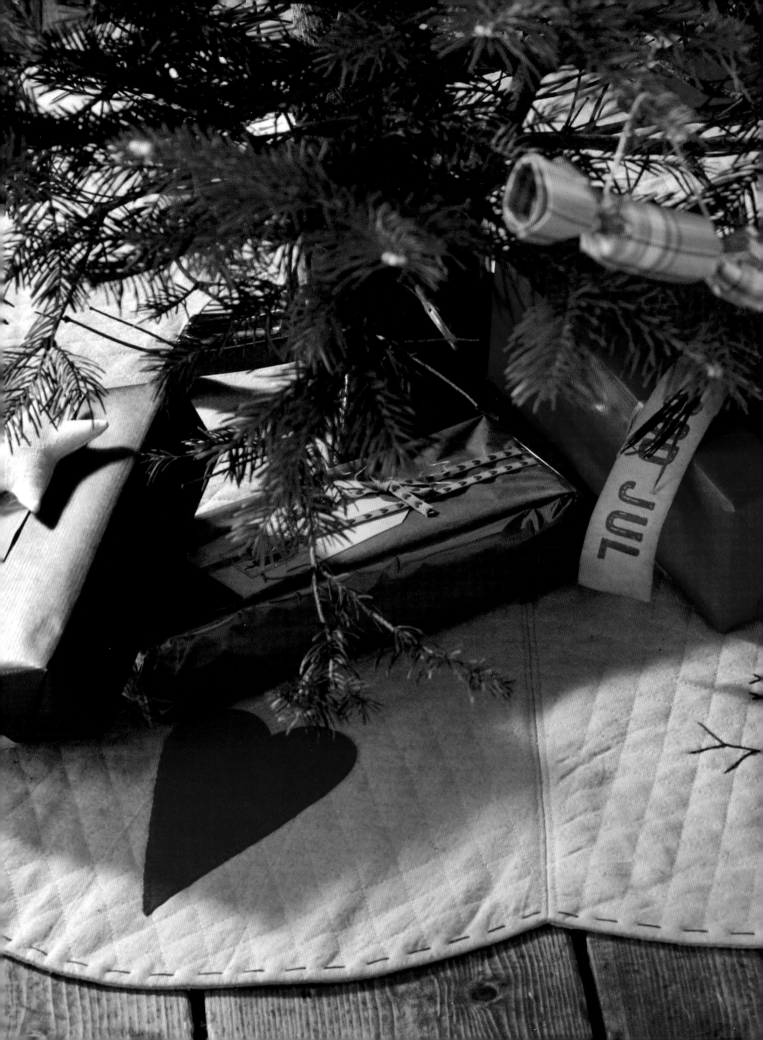

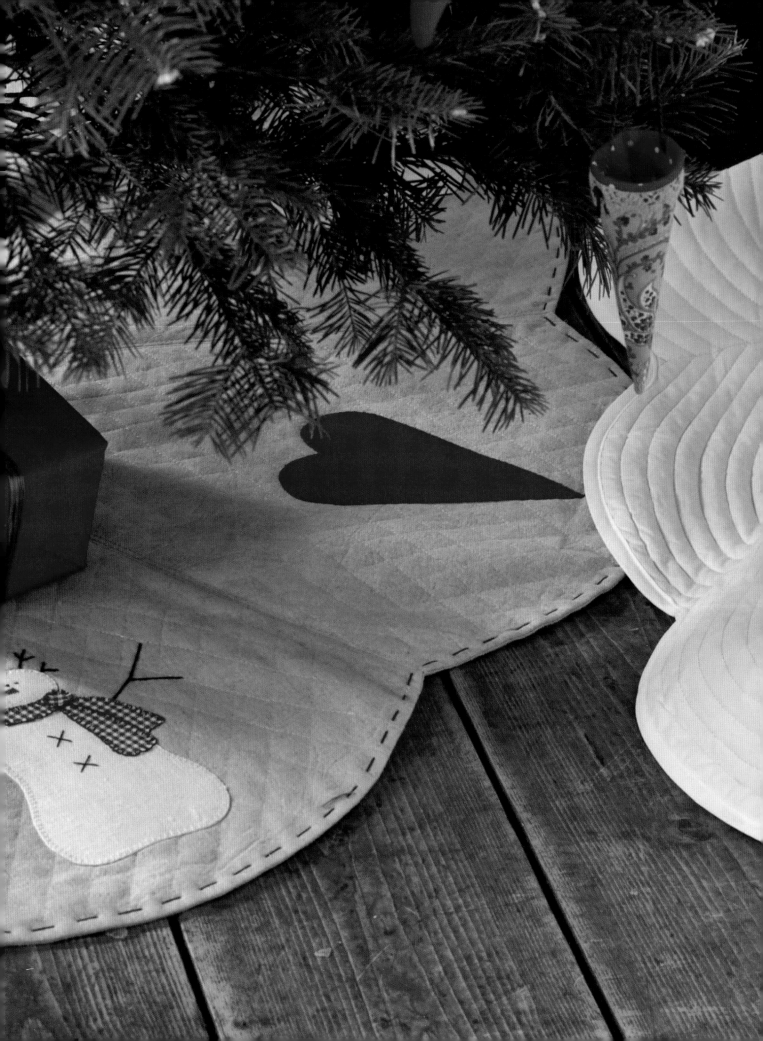

Tree Skirt With Bag

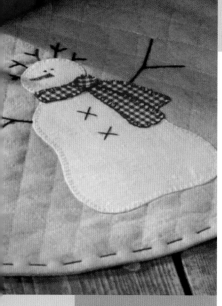

The pattern is on the folded insert at the back of the book.

Trace the pattern and place it on the fabric, paying attention to the orientation of the fabric. Cut out eight identical pieces.

Trace and cut out four snowmen, four scarves, and four hearts from the fabric you selected; cut another four snowmen, four scarves, and four hearts from fusible web. Appliqué the hearts and snowmen to the skirt pieces, 2 ½ inches from the curved edge. Sew blanket stitches around the motifs. We used three strands of embroidery floss for all the embroidery work in this project. The twigs on the head and arms are sewn with stem stitches. The eyes are made of French knots, and the carrot nose is sewn with satin stitches. We sewed two crosses on the snowmen's bellies for buttons.

When you have finished the appliqués, it is time to sew the pieces together. Sew the sections together in sets of two, with a snowman on the right of a heart. Iron the seams. Sew two lines of stitches along the seam on the right side of the fabric, one on each side of the seam; see figure A. Sew the pairs together in sets of two, iron, and add the stitching as in figure A. There should now be two large pieces left. Sew the two halves of the tree skirt together and iron. Sew the last two lines of stitching, which will go all the way across the tree skirt.

A

Place the tree skirt with the front facing down on the linen fabric for the back and use your hands to line up the parts. Cut the lining in the same size as the tree skirt. Sew a seam using a sewing machine around the edge of the tree skirt, but leave an opening of 9 ¾ inches in order to turn the tree skirt right side out. Cut small notches in the seam allowance all around the edge. Turn the tree skirt inside out and stitch up the opening by hand. Iron the edge and all seams on the tree skirt so it will lie flat on the floor. Sew basting stiches across the tree skirt in order to keep the backing in place. Sew a seam in the middle of each seam where the parts are sewn together. The seam will be invisible on the front side but will show on the back side and help keep the backing in place. Finally, sew a decorative seam using long basting stitches around along the edge of the tree skirt.

YOU NEED

Quilted linen fabric
White linen fabric
 for the snowmen
Red linen fabric
 for the hearts
Checked fabric
 for the scarf
Embroidery floss
Linen fabric for the back

Bag for the tree skirt

Cut two pieces of fabric for the bag, 13 1/4 by 16 1/2 inches, and two pieces of fabric for the lining the same size. We used the same fabric for the bag as in the tree skirt, but we used linen for the trim on top. Cut a piece of fabric for the trim 7 by 26 inches. Trace the heart on fusible web and iron it onto the fabric chosen for the heart. Place the heart in the middle of one of the fabric pieces, 3 1/2 inches from the bottom of the bag. Sew around the heart with blanket stitches. (Embroider the year alongside the heart if you wish; see picture.) Place the fabric pieces for the outside of the bag together, right side to right side, and sew them together. Do the same with the lining. Iron the parts. Turn the lining bag inside out and place the fabric piece inside the lining with the wrong sides against each other.

Sew the folded border and the rest of the bag like the candy gift bag on page 74.

Gift Wrapping

To receive a gift is a pleasure for everyone, young and old. It is extra nice to give away gifts that are wrapped nicely and with care. This doesn't need to be very time consuming. Here you can see a few examples of gifts that are wrapped with fabric, cellophane, wrapping paper, homemade decorations, and homemade stamped tags.

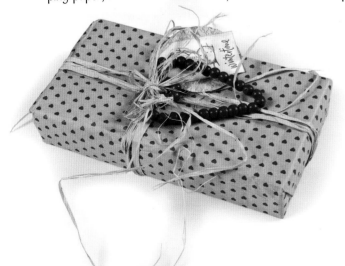

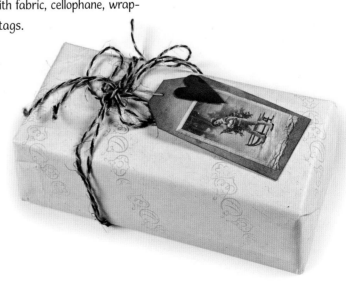

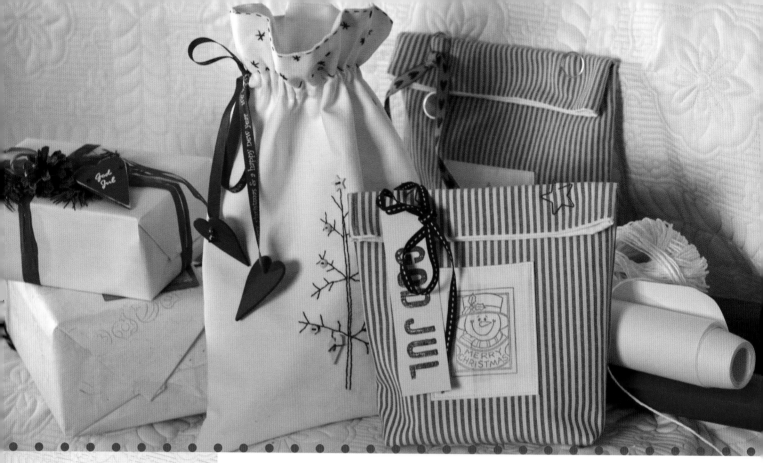

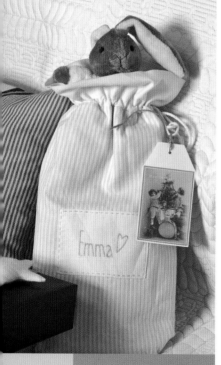

YOU NEED

Fabric for the bag
Fabric for the trim
Quilt batting
Embroidery yarn
String

Cloth Gift Bags

The size of these gift bags can be adjusted depending on what's going to be inside. The bag piece and lining piece must be cut in the same size. Sew the bags following the intructions below.

Gift bags with name

Cut a piece of fabric 9 by 27 $1/2$ inches for the bag, and a piece of fabric 6 $1/4$ by 17 $1/2$ inches for the border. Cut an additional piece of fabric to embroider the name on, 4 by 5 inches and a piece of batting 3 by 4 $1/4$ inches.

Put letters on a piece of tracing paper (you can trace the letters on page 9 if you like), and transfer the letters and the little heart below to the cloth. Place the batting in the middle underneath and stitch the motif with stem stitches. Fold an edge of $1/2$ inch to the back and iron. Sew a line of decorative basting stitches around the outside, $1/16$ inch from the edge. Sew the embroidered patch to the bag 6 inches from the top edge. Continue to sew the bag the same way as the candy gift bag on page 74.

Gift bag with decorative patch

Cut one piece of fabric and one piece of lining. Both pieces should be 8 by 20 1/4 inches.

PATCH

The size of the stamp will determine the size of the patch. Stamp a motif on a light-colored fabric. Cut the patch out in the desired size, fold the edge 1 cm inwards, and iron.

BAG

Sew the patch onto the front side of the bag with a sewing machine, putting the seam right by the edge. Fold the fabric in half right side to right side and sew the side seams; then iron the seams. Fold the lining right side to right side and sew the side seams, remembering to leave a 2-inch opening. Iron the seams. Fold the corners the same way as for the gingerbread cookie cutter bag on page 80, putting the seam 1 inch from the tip. Reverse the lining and put it inside the bag, right side to right side and edge to edge at top. Sew the two parts together. Turn the bag and sew up the opening in the lining by hand. Place the lining bag inside the fabric bag, but leave 1/16 inch of lining at the top; iron.

 To close the bag, fold the top down and hold it closed with decorative paper clips on the folded edge. Make matching tags and decorate with ribbons.

Gift bag with fringed patch

Cut a piece of fabric and a piece of lining, each 9 1/2 by 25 inches.

PATCH

The size of the stamp will determine the size of the patch.

 Stamp a motif on light-colored fabric. Cut the patch out in the desired size and fold the edge 1/2 inch inwards on each side and iron. Place the patch on a piece of linen fabric that is 1/2 inch larger than the patch on all sides. Sew the patches to the front piece 6 1/2 inches from the top edge. Pull out the threads in the edges around the linen fabric to make fringes.

 The bag is made the same way as the gingerbread cookie cutter bag on page 80, but this bag does not have the corners folded in.

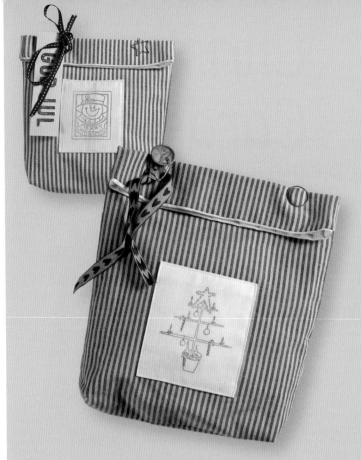

These gift bags can be used again and again.

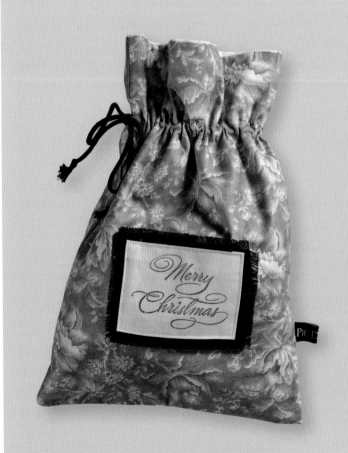

Christmas Cards on a String

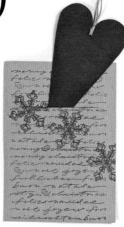

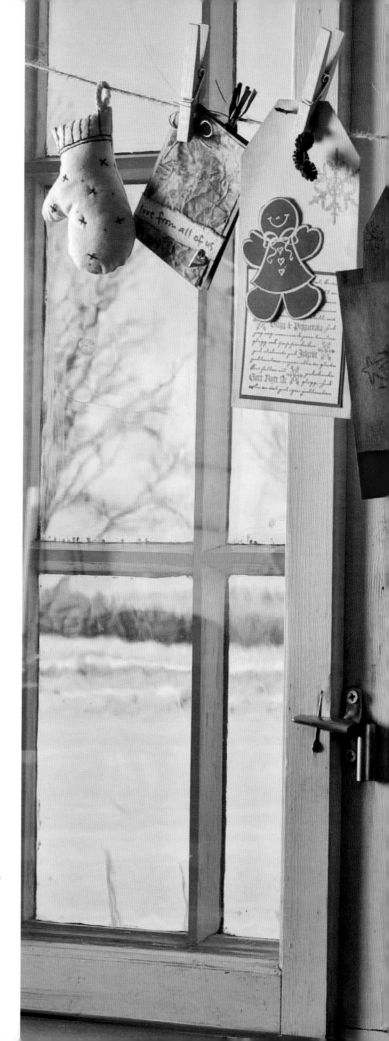

Cut a piece of cardstock 4 by 5 1/2 inches. Stamp writing all over the card and add stamped snowflakes in a color that will match the heart. Make a cut 2 1/2 inches wide with a craft knife, 1 1/2 inches from the top edge. Make another cut, 1 1/2 inches wide, 3 inches from the top edge. Cut a heart and make a hole for a string. Our heart is sponged using a distressed-ink pad to give it an old look.

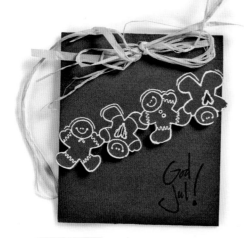

Cut a piece of brown cardstock 3 1/2 by 11 inches. Stamp a motif across the front of the card and cut clean around the motif on one side; see picture. Fold the card in half. Make two holes 1/8 inch from the top edge through both the front and the back of the card. Thread rafia through the holes and make a bow. Stamp text on the card.

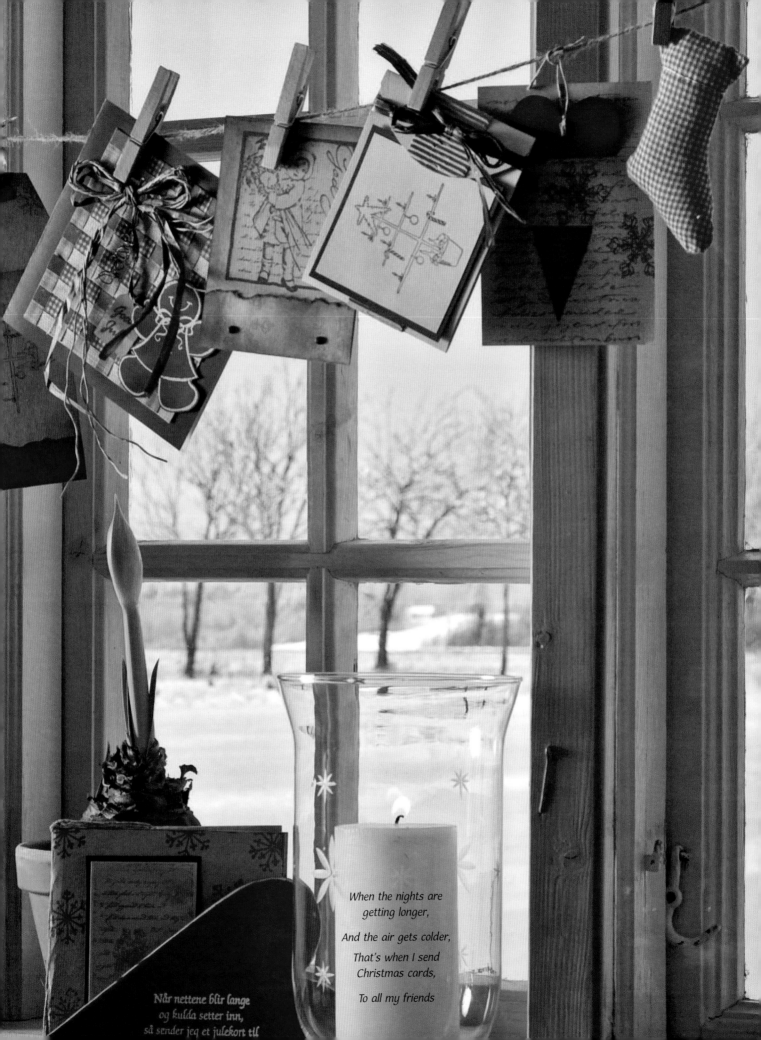

When the nights are
getting longer,

And the air gets colder,

That's when I send
Christmas cards,

To all my friends

Når nettene blir lange
og kulda setter inn,
så sender jeg et julekort til

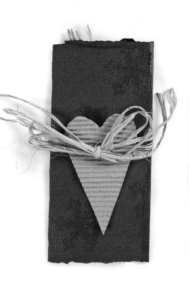

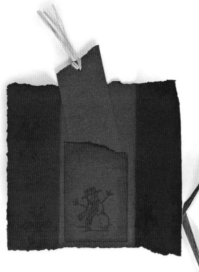

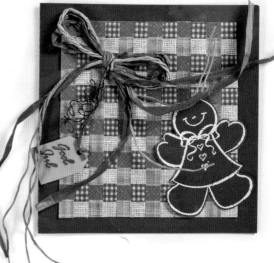

Rip a piece of cardstock 6 by 8 inches. Fold the card in three parts. To make a pocket with a tag inside the card, cut a piece for the pocket from the same card stock, 2 1/2 by 4 inches. Rip the top edge on a diagonal. Sponge the piece with brown ink, then attach it to the card with a thin piece of double-sided tape. Make a tag that will fit inside the pocket, punch a hole in it, and add ribbon or rafia. Sponge brown ink around the card on both sides and stamp on snowflakes. Cut a heart from corrugated paper and make two holes in the middle. Thread rafia through the heart, and close the card by tying a bow on the heart.

Cut a piece of brown cardstock 6 by 11 3/4 inches and fold the card together. Cut a piece of decorative paper 5 by 5 inches. Glue the paper onto the card. Emboss a brown gingerbread figure with white embossing powder. Cut out the figure and attach it to the card; see picture. Tie a bow of rafia. Twist some wire into a spring and attach it around the bow. Glue the bow to the card. Tie a stamped mini tag to the bow.

Tip:
Twist the wire around a knitting needle to get nice circles.

Card Holder

The pattern is on the folded insert at the back of the book.

Trace the pattern for the heart and the back piece on a plywood board. You need a block of wood 1 1/4 by 5 inches, and about 1/2 inch thick for the bottom. Cut out the pieces and sand them. Paint all the pieces, and sand the edges when the paint is dry to give the project an old look. Stamp or emboss suitable text onto the heart. Glue the pieces together, keeping pressure on the pieces until the glue has dried.

YOU NEED

Plywood 1/8 inch thick
Block of wood
Stamp
Embossing supplies
Craft paint

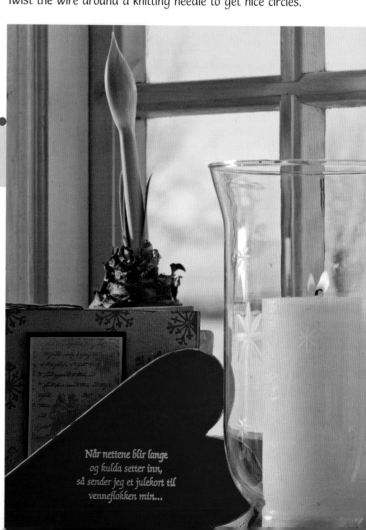

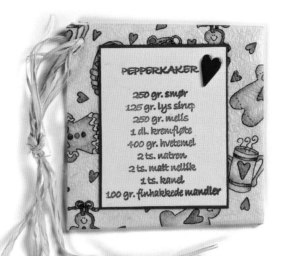

Cut a piece of cardstock 4 by 10 1/2 inches. Fold the card so the front side ends up being 5 inches, and attach the edges with a thin piece of double-sided tape to make a pocket. Glue a strip of paper that is ripped on one of the long sides to the card; see picture. Make a tag measuring 3 by 6 inches. Stamp the desired motifs on the card and tag. Glue a paper patch to the tag where you will put the hole for the string. Sponge the parts of the card with brown ink. Place the tag in the card; see the picture on page 94-95.

Make a cute note with a gingerbread recipe, and bake or sew some gingerbread men to complete the gift.

Cut a piece of cardstock 4 by 11 3/4 inches. Rip off 1/4 inch at one of the short ends and fold this end over by about 1 inch. Make two small holes through both layers of paper 1/2 inch from the folded edge. Fold the rest of the card so that the front overlaps the folded part, just coming up to the holes. Stamp a motif on the front of the card. Sponge the card with brown ink. Hold down the short flap with brads through the holes.

In the picture, you can see what the card looks like before you close it. On page 95, you can see how the card looks when it's closed.

Cut a piece of cardstock 6 by 11 3/4 inches. Fold the card and stamp snowflakes on the front side. Cut a piece of light-colored cardstock 2 1/2 by 4 inches. Glue it to a piece of cardstock in a contrasting color and cut around the edge, leaving a border of 1/16 inch. Stamp a motif on the patch.

Tip:
If you want to do something extra, send a bag of spices with the Christmas card. Put the card and the spices in a cellophane bag and glue a patch with the address on the outside.

Cut a piece of light-colored cardstock 4 by 11 $^3/_4$ inches. Fold it and cut as shown in the picture. The finished card measures 5 $^1/_2$ by 4 inches. Cut a strip of corrugated paper 1 $^1/_2$ inches wide and 12 inches long, and glue it to the middle of the card. Cut a light decorative patch 3 $^1/_8$ by 3 $^1/_8$ inches. Glue it to a piece of paper in a contrasting color. Cut around the patch so $^1/_{16}$ inch of the contrasting paper will show. Stamp a motif on the patch and glue it onto the card. Fold the card and close it with rafia.

Cut a piece of cardstock 4 by 8 $^1/_4$ inches. Fold it in thirds so you end up with a card measuring 2 $^3/_4$ by 4 inches. Use a thin piece of double-sided tape to attach the right side to the middle of the card to form a pocket. Cut a card 2 $^1/_4$ by 3 $^3/_4$ inches to go inside the pocket. Make a hole in the top of the card and attach a piece of rafia. Decorate the front of the card with decorative paper. Rip off a strip of light-colored paper, stamp on text or write a message of your own, and sponge the edges of the paper with brown ink. Glue it on a slight diagonal across the card and decorate with a decorative brad and a bow made of string.

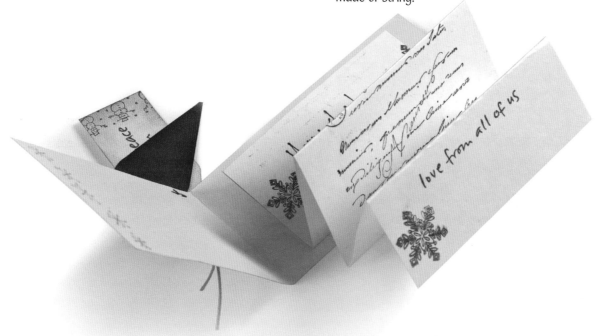

Do you have more to say than will fit on a regular Christmas card? Write a Christmas letter and fold the paper like an accordion. Glue it to the inside of the card. Close the card and tie a ribbon or string around the card.

Gift Tags

A homemade gift tag will give the present a personal touch and make it something special. You don't need much equipment to make gift tags. We made patterns for two different tags (find them on page 107), but adjust the size to the stamp you will use to decorate them. You will find the pattern at the back of the book.

Cut out a tag and stamp on a motif and text. Use a sponge and apply brown ink to give the tag an old look. Make a hole and attach rafia.

Stamp a design with a long stamp on a piece of brown recycled paper. Cut out the motif. Don't cut right next to the motif; leave some space around the edges. Use a sponge to apply ink from a brown ink pad. Glue the paper to a piece of cardstock in a contrasting color and cut it out so you leave $1/8$ inch around the edge. Make a hole at the corner and tie a string to the card.

Cut a circle out of cardstock. Cut a tag and stamp a design and text on it. Use a sponge and apply ink from a distressed-ink pad to give the tag an old look. Glue the tag to the circle, make a hole, and attach a string.

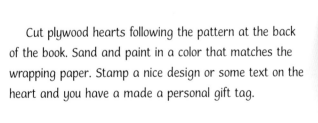

Cut plywood hearts following the pattern at the back of the book. Sand and paint in a color that matches the wrapping paper. Stamp a nice design or some text on the heart and you have a made a personal gift tag.

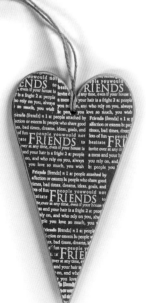

Here we used a sticker as decoration. First, find a sticker you would like to use and then cut a tag in the right size. Apply the sticker to a piece of decorative paper and cut or tear to leave a frame around the sticker. Glue this to the tag and cut out a small heart to glue on top. Make a hole and attach a string.

Advent Calendar

The pattern is on the folded insert at the back of the book.

A advent calendar makes the time before Christmas Eve go by faster. You don't need to sew 24 bags for this calendar; you can hang small gifts on the tree, or Christmas crackers with a lottery ticket inside.

Trace the pattern on the balsa board, marking where the tacks should go. Cut out the tree. Sand the surface and edges. Stain the wood the color you want. Put in the tacks when the tree is dry. Make a hanger on the back by screwing two screws 10 inches from each other and attaching a wire between them.

CALENDAR BAGS

Cut a piece of fabric 4 by 13 $\frac{1}{2}$ inches. Fold the fabric in half, right side to right side, and sew along the edges. Sew a zigzag seam across the seam allowance and the cut edge on top so it won't fray. Cut a strip of fusible web 1 inch wide and use it to iron down the top edge. Turn the bag inside out and iron. Put a gift in the bag and tie with ribbon or rafia.

CALENDAR TAGS

Cut 24 small tags. Stamp or write the numbers from 1 to 24 on them and decorate with different stamped motifs. Sponge the tags with brown ink to create a vintage look.

YOU NEED

For the calendar:
Balsa board, 23 $\frac{1}{2}$ in. wide, $\frac{1}{16}$ in. thick
Black thumbtacks
Stain

For the calendar bags:
Various cotton fabrics
Fusible web
Ribbon/string

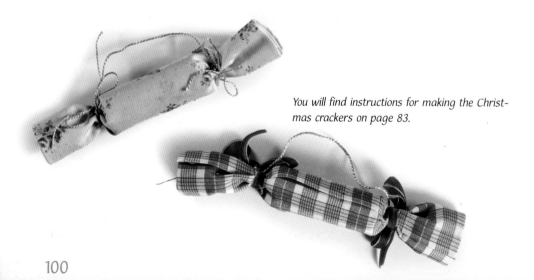

You will find instructions for making the Christmas crackers on page 83.

100

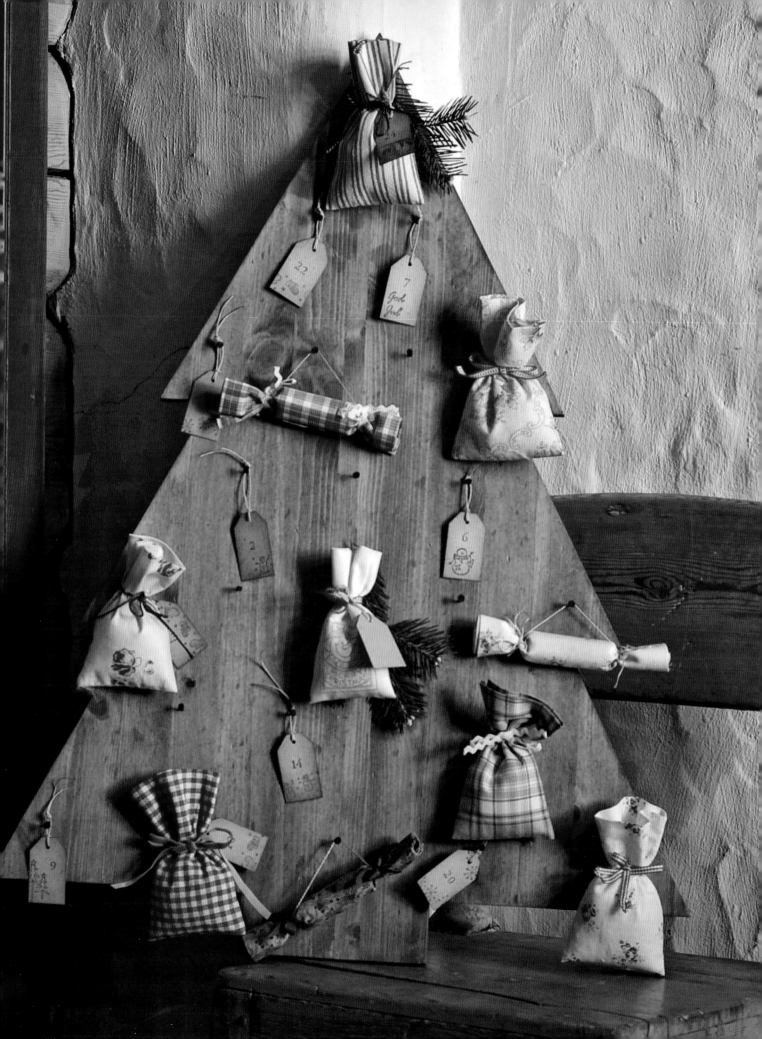

Christmas Day Gift Bag

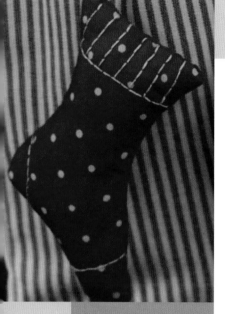

The pattern is on page 68.

Instead of Christmas stockings, you can make a Christmas bag with little stockings attached to it. This is a nice surprise for the kids on Christmas Day.

STOCKINGS

Fold the fabric in half and trace the pattern from page 68, remembering to mark the opening. Sew around the edge and cut it out. Turn the stocking inside out, iron, and stuff with fiberfill. Cut a piece of string 2 inches long to hang the stocking. Fold the string into a loop and place it inside the opening. Stitch up the opening. Sew some decorative basting stitches around the toe, heel, and top edge.

BAG

Cut one piece of fabric for the outside and one piece of lining fabric. The pieces should be $32^3/_4$ inches long and $12^1/_2$ inches wide. Cut a piece of string 13 inches long to hang the stockings.

Thread the stockings on to the string. Fold the fabric piece in half, right side to right side, but put the string with the stockings between the layers. Attach the string $7^1/_2$ inches from the top at each side with pins. Stitch up the side seams, leaving an opening $1^1/_2$ inch wide, 2 inches from the top on each side. This is the opening for the drawstring casing. Iron the seams. Fold the lining in half, right side to right side. Sew the side seams, remembering to leave an opening. Reverse the lining and iron the seam allowance for each side. Place the lining inside the bag, right sides together, and sew them together. Turn the bag inside out and sew up the opening. Place the lining piece inside the bag, leaving some of the lining showing at the top, and iron down the edge. Sew two seams for the casing, make sure the openings are between these seams. Thread the drawstrings through the casing the same way as in the egg bag (page 36). Tie a knot at the ends of the strings.

YOU NEED

Fabric for the bag
 and lining
Various fabrics
 for the stockings
Fiberfill
String

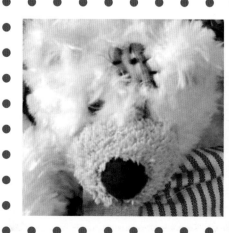

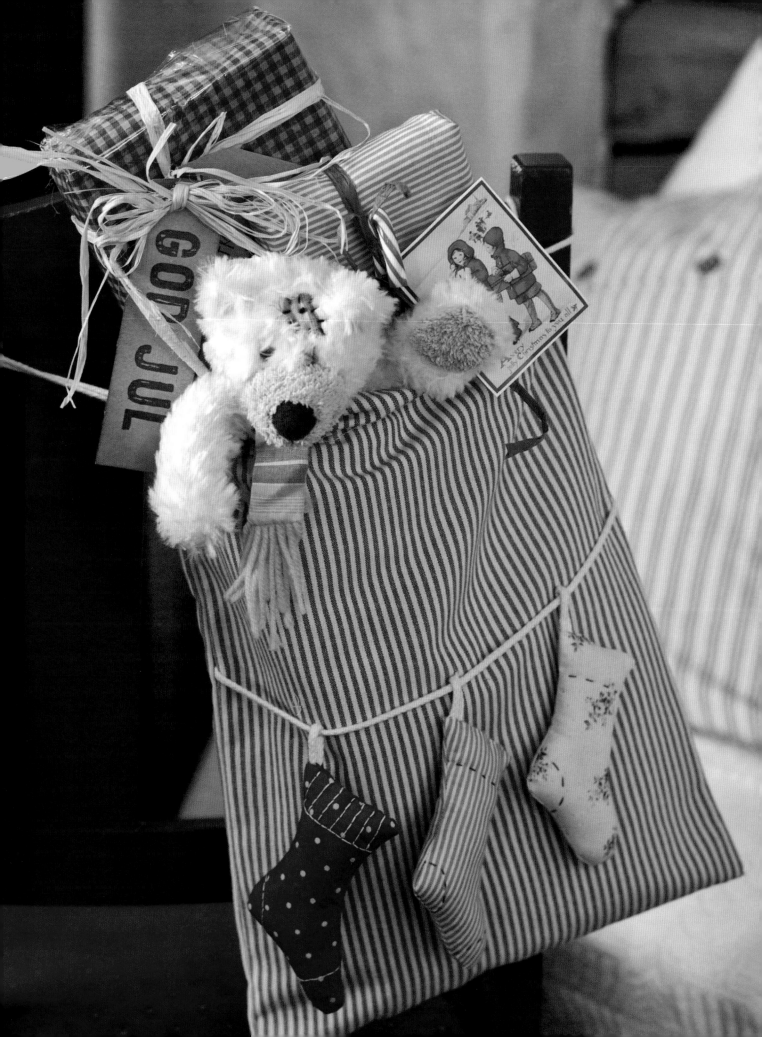

Door Wreath

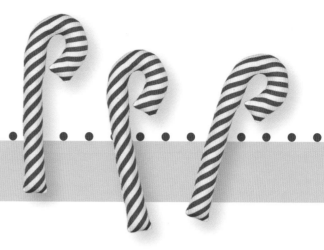

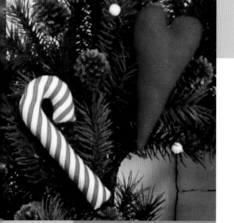

YOU NEED

Twig wreath approximately 20 inches in diameter
Cotton fabric
Linen
Fiberfill

HEARTS

Fold the fabric in half and trace the "Heart 1" pattern (from the folded insert) three times, marking the openings. Sew around the hearts and cut them out. Cut notches in the seam allowance and turn them inside out. Iron and stuff with fiberfill. Stitch up the opening.

CANDY CANES

Sew three candy canes in the smallest size. See the instructions on page 45.

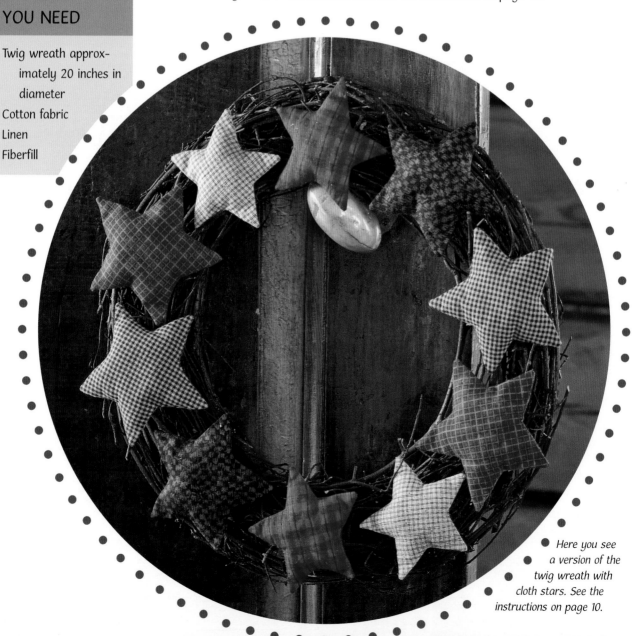

Here you see a version of the twig wreath with cloth stars. See the instructions on page 10.

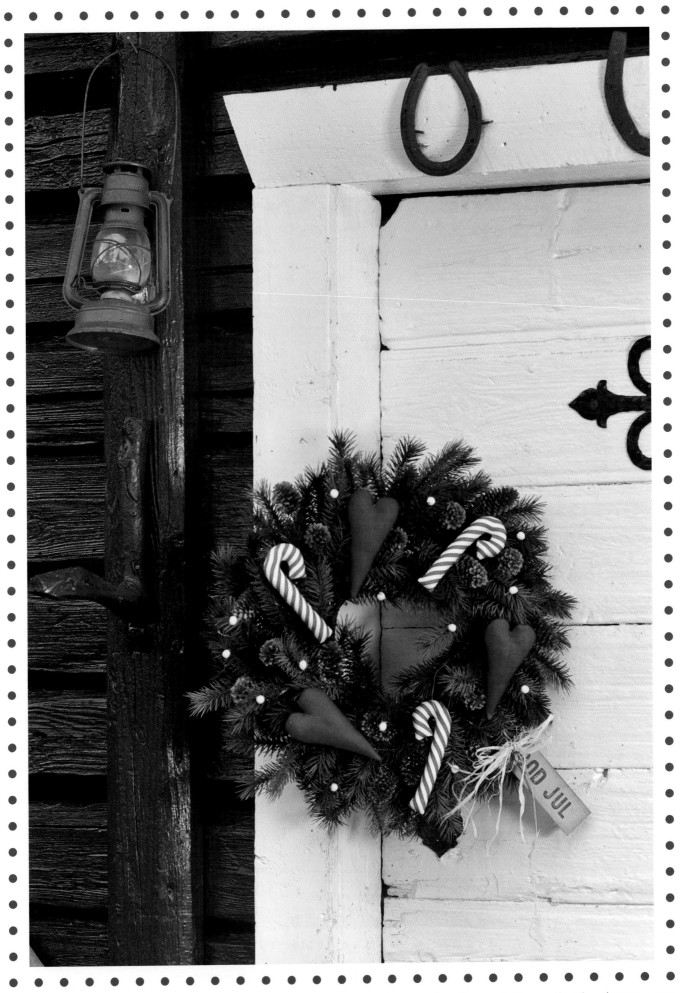

You can also use an artificial wreath and glue pinecones, white pompoms, hearts, and candy canes to the wreath with a glue gun. 105

Acknowledgments

We want to send a big thank you to the arts and crafts department at Cappelen Damm and Toril Blomquist that has given us the opportunity to publish this book. Thank you to stylist Hege Barnholt and photographer Helge Eek for their great work. Thanks to Kathrine at Kathrine's Quiltestue for great fabrics. It's always a pleasure to walk into your store.

Egil, what would we do without you and your workshop? Thank you for all the hours you spent helping us. Thanks to Husfliden Oppdal and Sonja for fabrics and materials. Thank you for great collaboration. Thank you to Sømsenteret A/S and Håvard Kilde for helping us with buying a sewing machine. Thank you to Frank Smed for great hangers, and to Muchmore and Hildegunn for paper and stamp equipment.

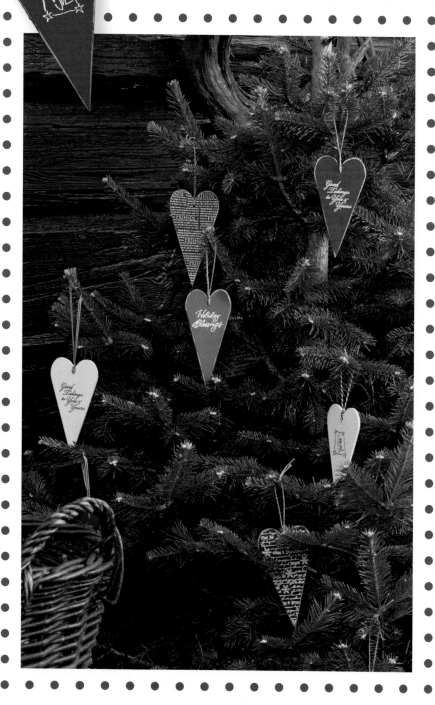

Also a big thank you to all our friends for contributing with great ideas and suggestions, and to our families for believing in our project and helping us during the process.

A special thank you goes to Bakker Gjestegård for letting us use their beautiful place as background for many of our photos. Also thank you to all contributors and those who lent us props for the shoots.

The hearts on this tree are made from the heart pattern on page 52. Follow the instructions for the plywood hearts on page 30. If you varnish the hearts, you can hang them on a little tree outside by the front door.

106

Gift tags

Trees for the
ice-scraper mitten

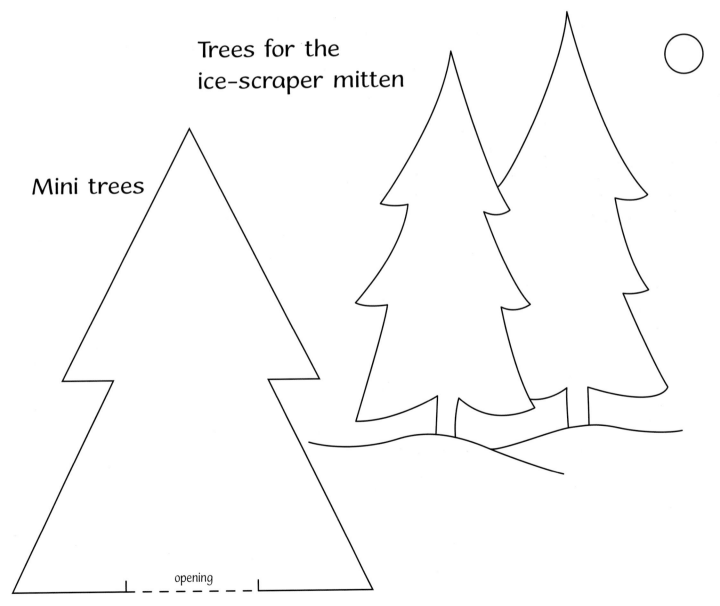

Mini trees

opening

Snowman for the Christmas tree skirt

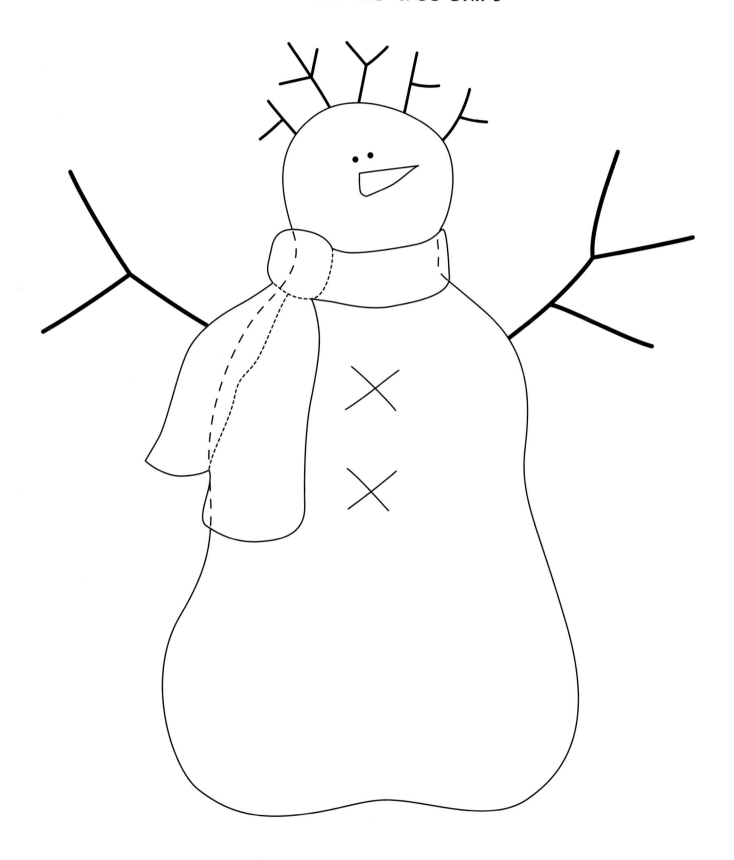

Hat for the large and small snow-man

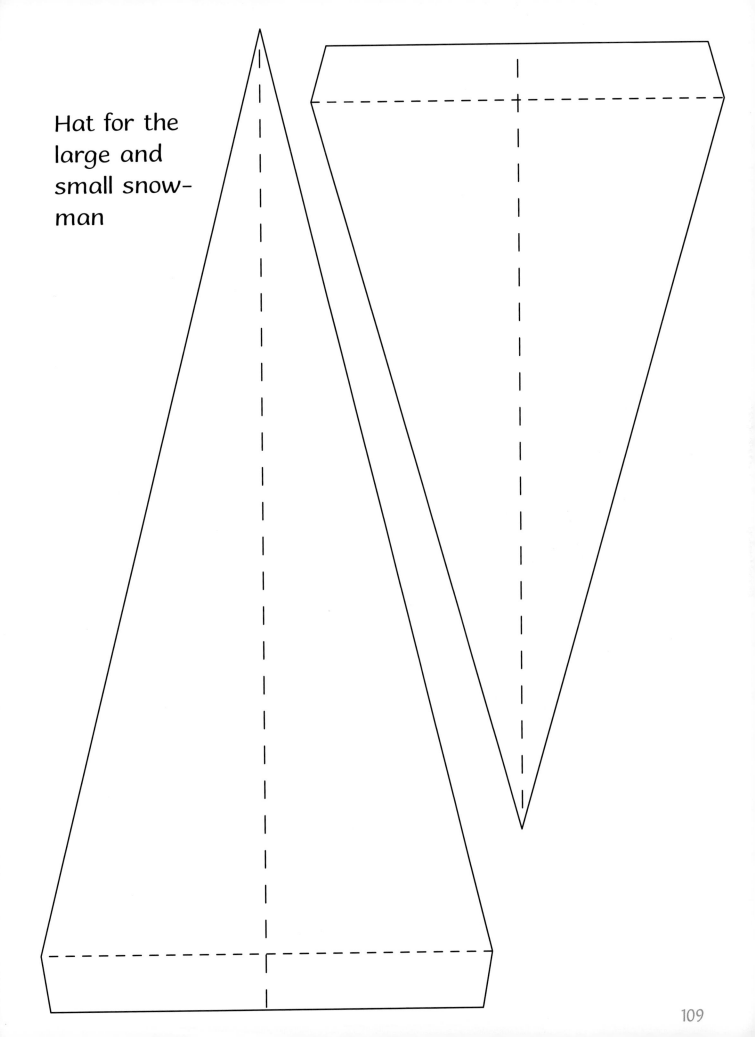

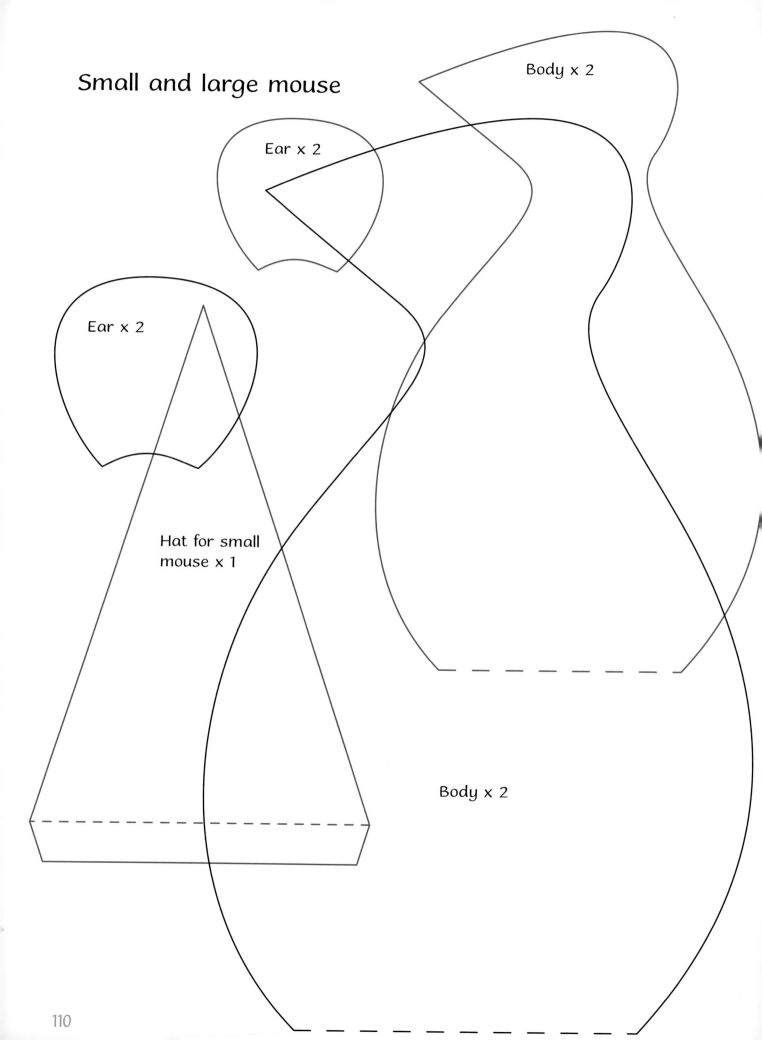

Small and large mouse

Body x 2

Ear x 2

Ear x 2

Hat for small
mouse x 1

Body x 2

Plywood angel

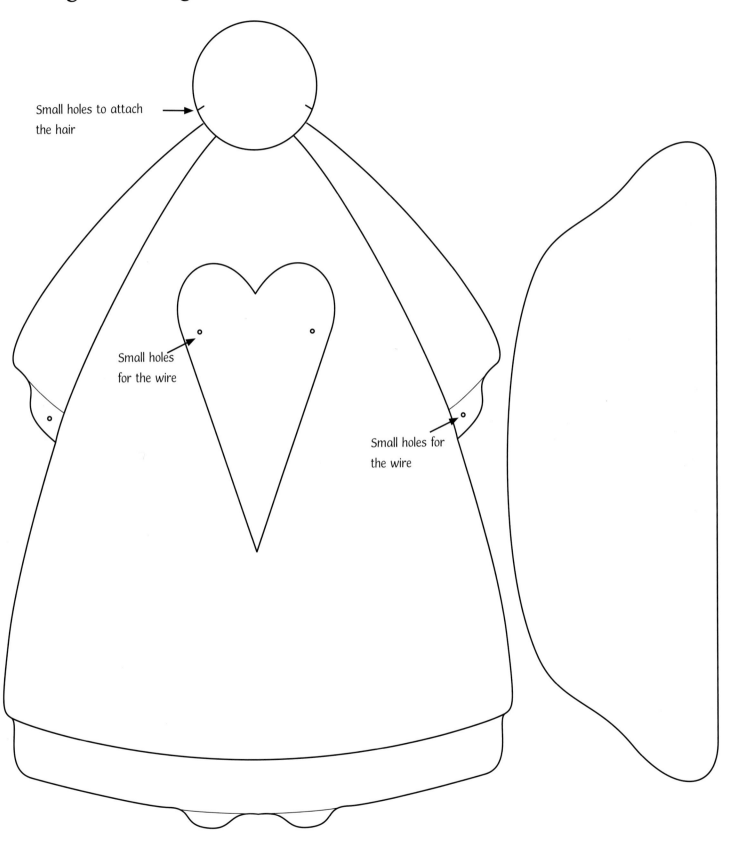

Small holes to attach
the hair

Small holes
for the wire

Small holes for
the wire

Pillow with heart